Little Thoughts
with Love

ANNE GEDDES

Little Thoughts with Love

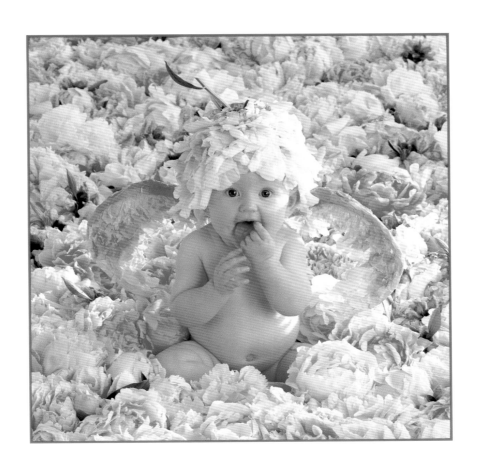

There are only two lasting bequests
we can hope to give our children.
One of these is roots;
the other, wings.

Hodding Carter III (1935–)

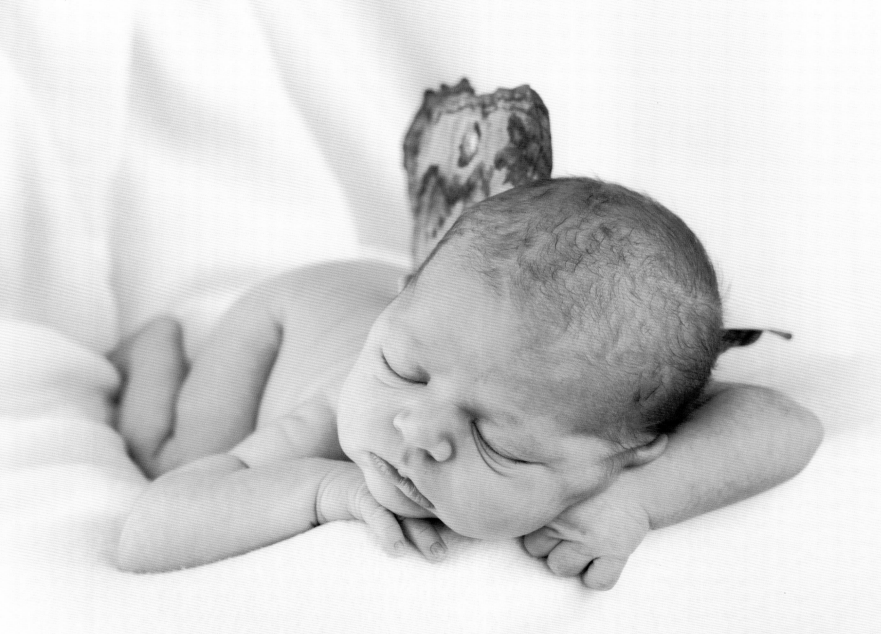

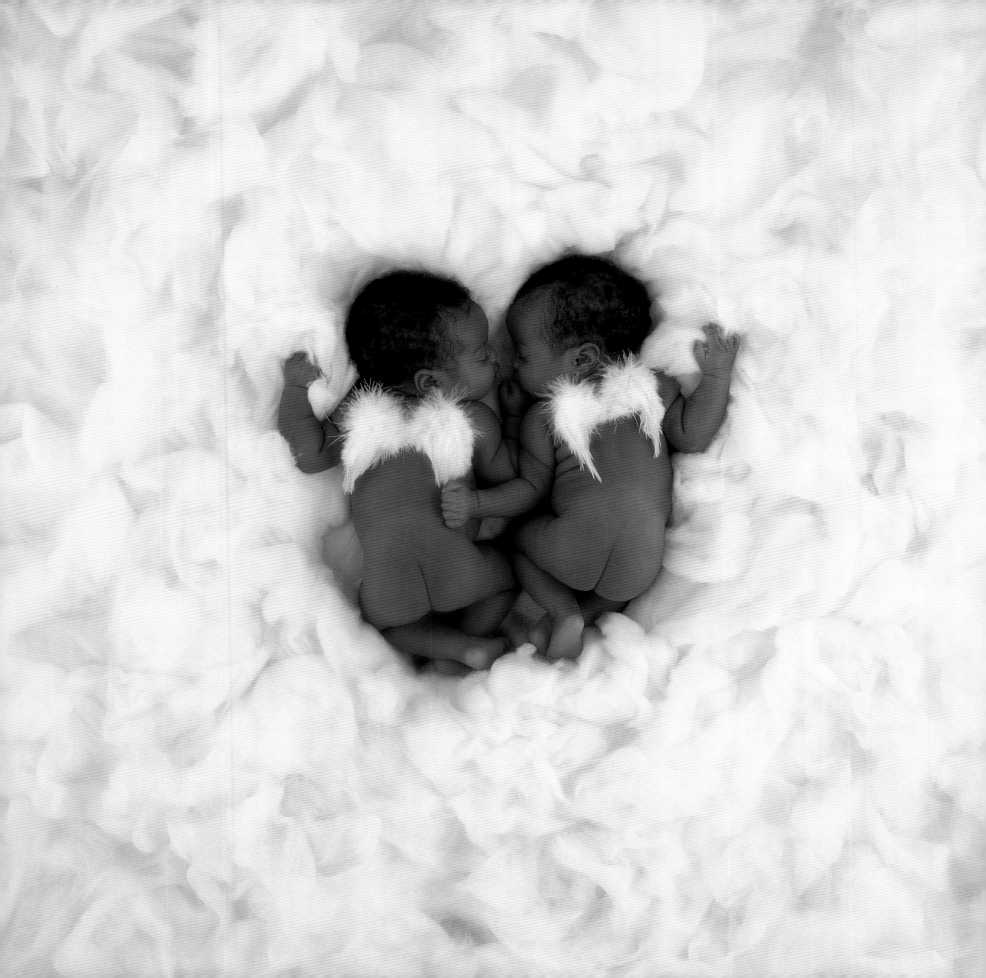

Kiss your children goodnight,
even if they are already asleep.

H. Jackson Brown, Jr. (1940–)

Tears ... the diamonds of the eye.

Rev. Dr. Davies

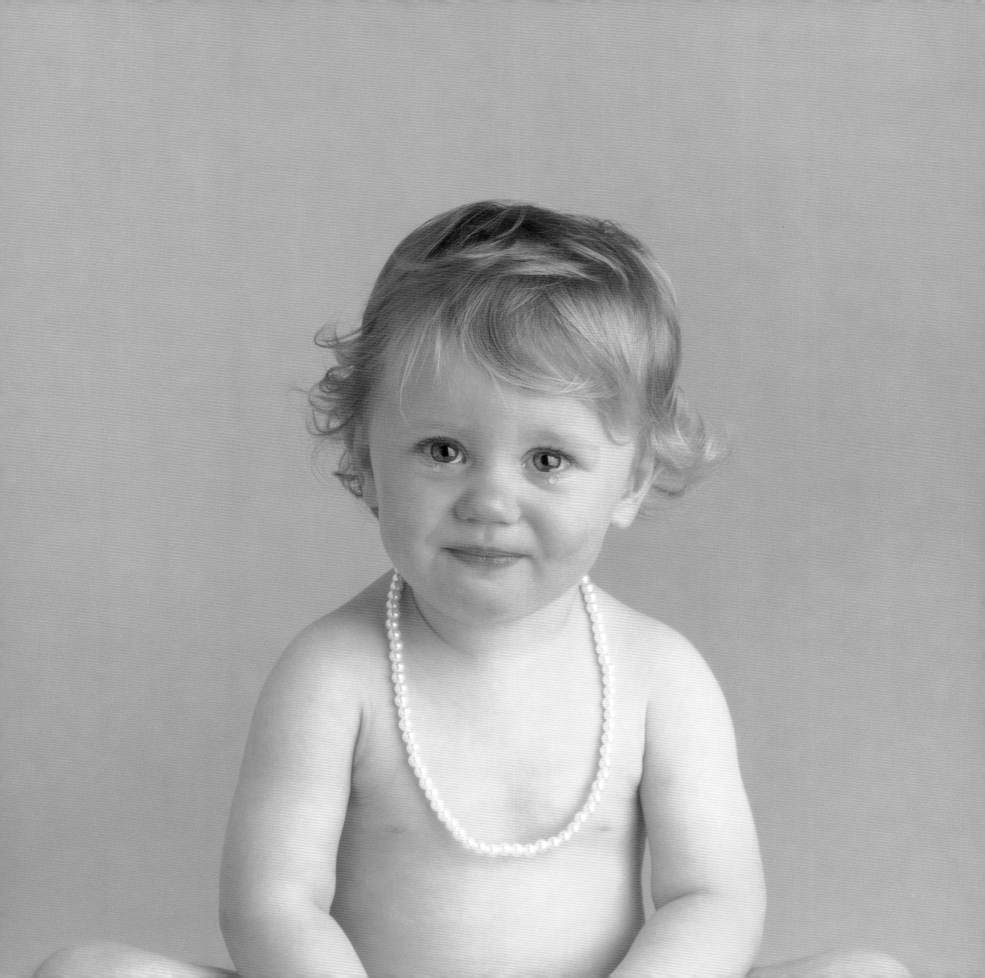

We can do no great things —
only small things with great love.

Mother Teresa (1910–1997)

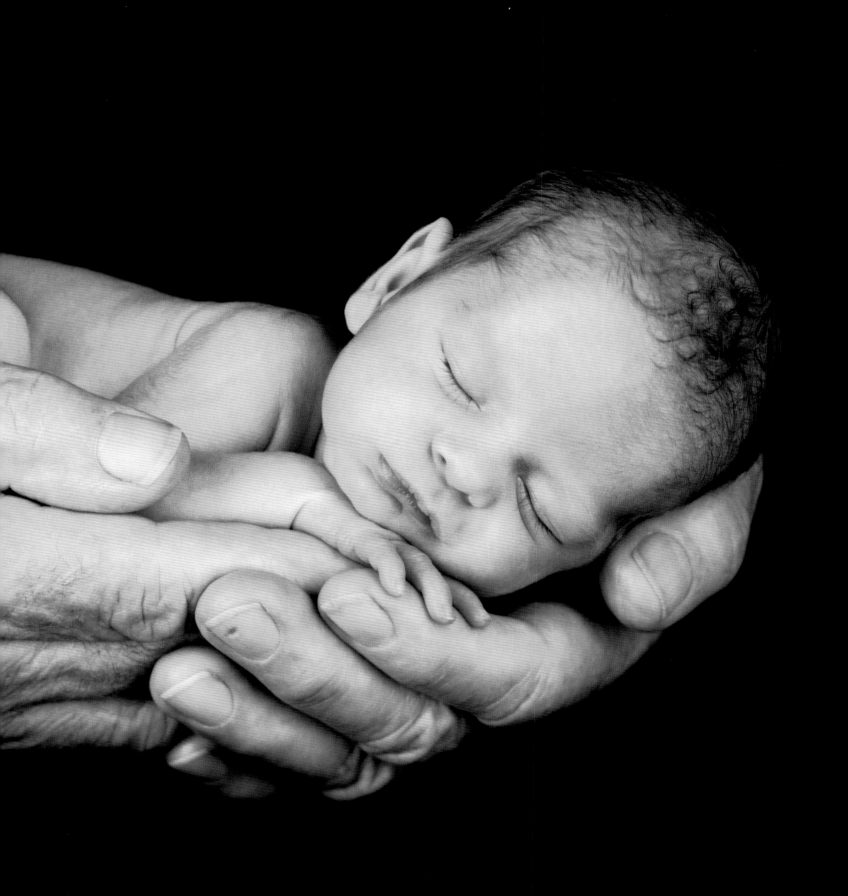

*D*o you believe in fairies?

... If you believe, clap your hands!

J. M. Barrie (1860–1937)

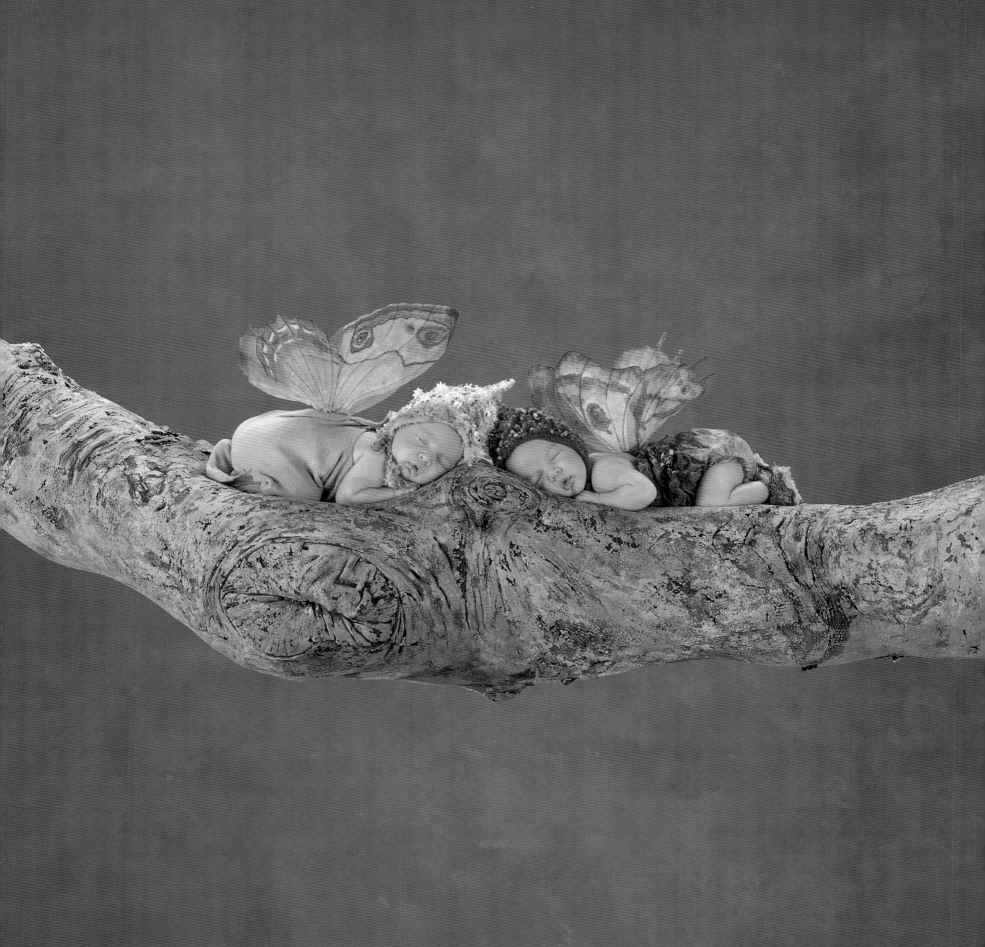

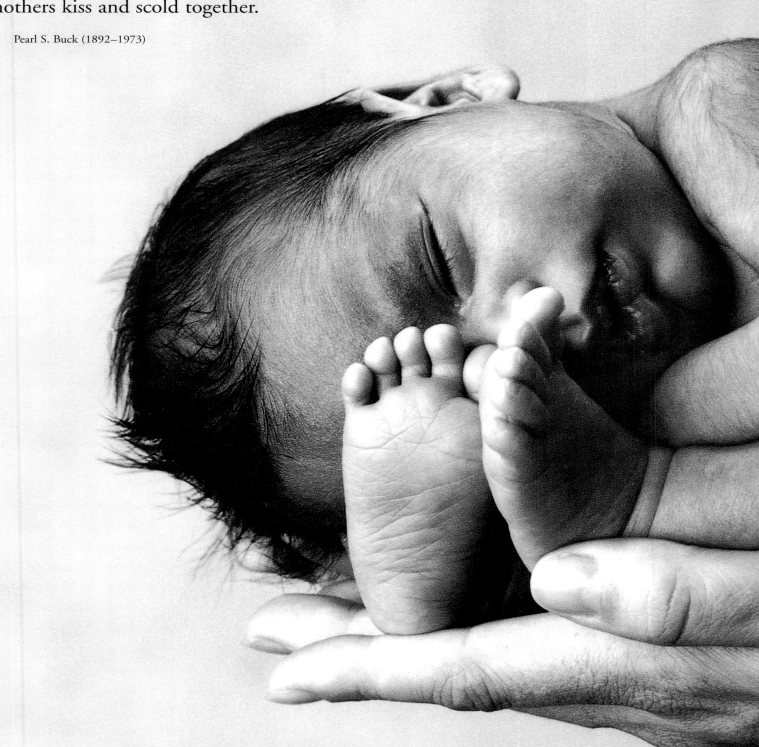

*S*ome are kissing mothers
and some are scolding mothers,
but it is love just the same,
and most mothers kiss and scold together.

Pearl S. Buck (1892–1973)

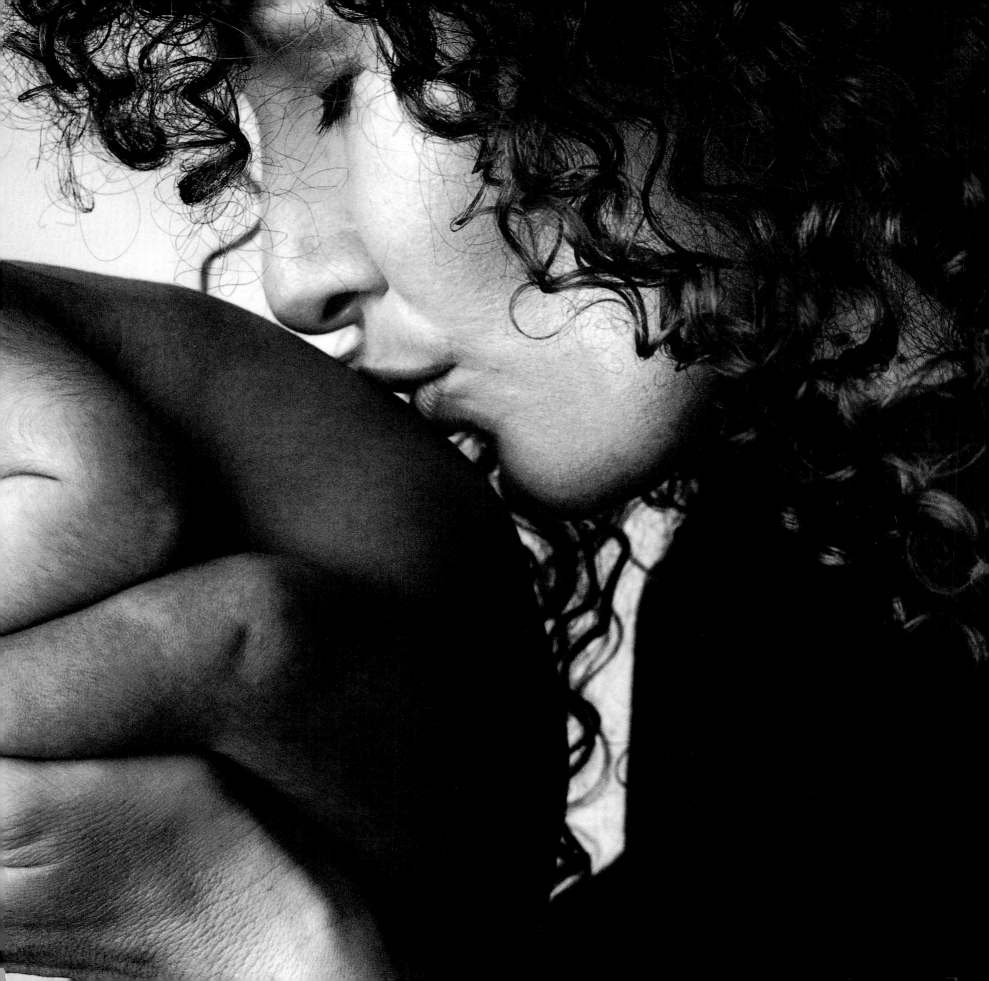

How soft and fresh he breathes!
Look! He is dreaming! Visions sure of joy
Are gladdening his rest; and, ah! who knows
But waiting angels do converse in sleep
With babes like this!

Bishop Coxe (1818–1896)

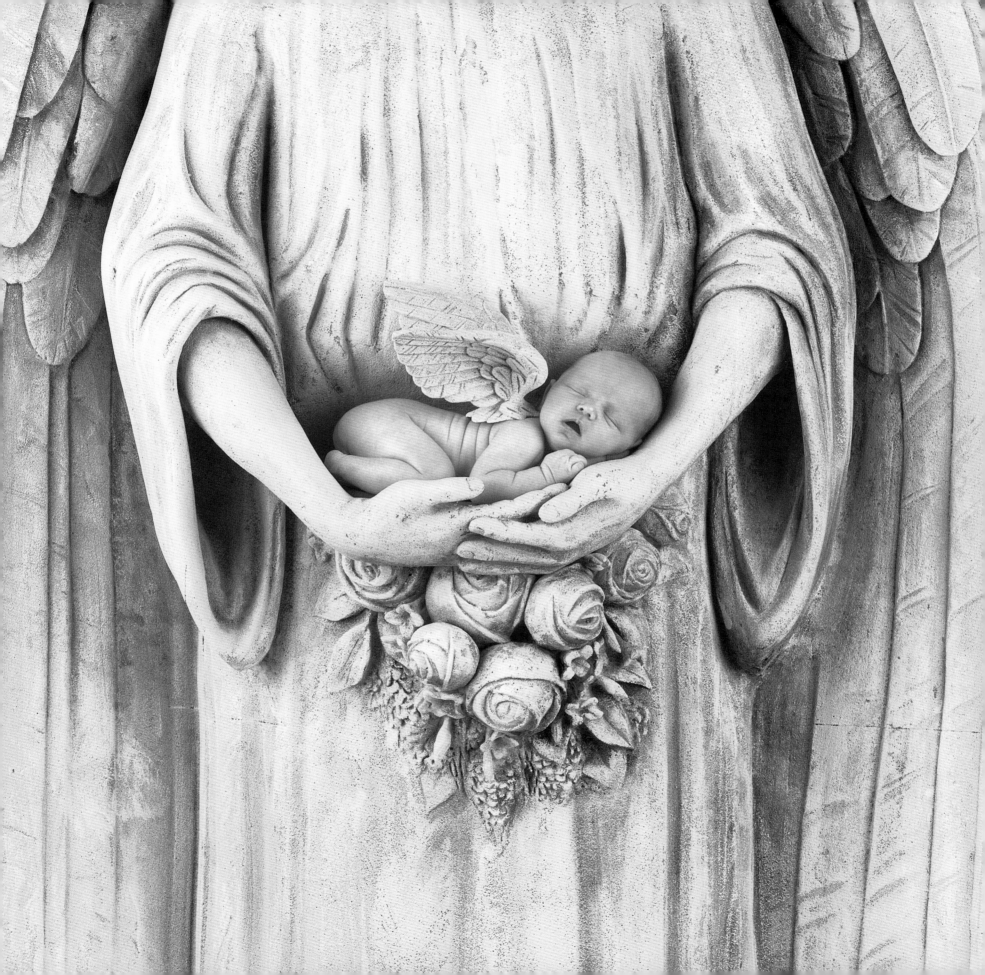

Flowers always make people better,
happier, and more helpful;
they are sunshine,
food and medicine to the soul.

Luther Burbank (1849–1926)

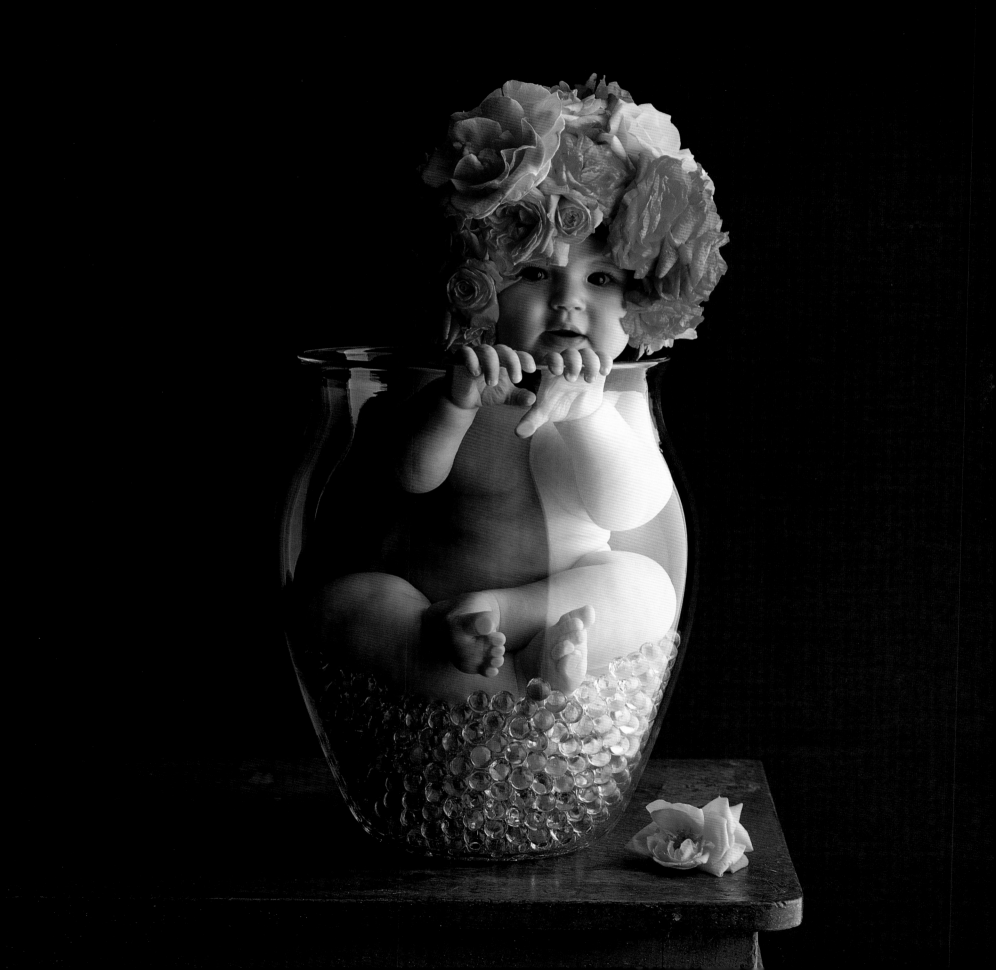

\mathcal{A} mother understands
what a child does not say.

Proverb

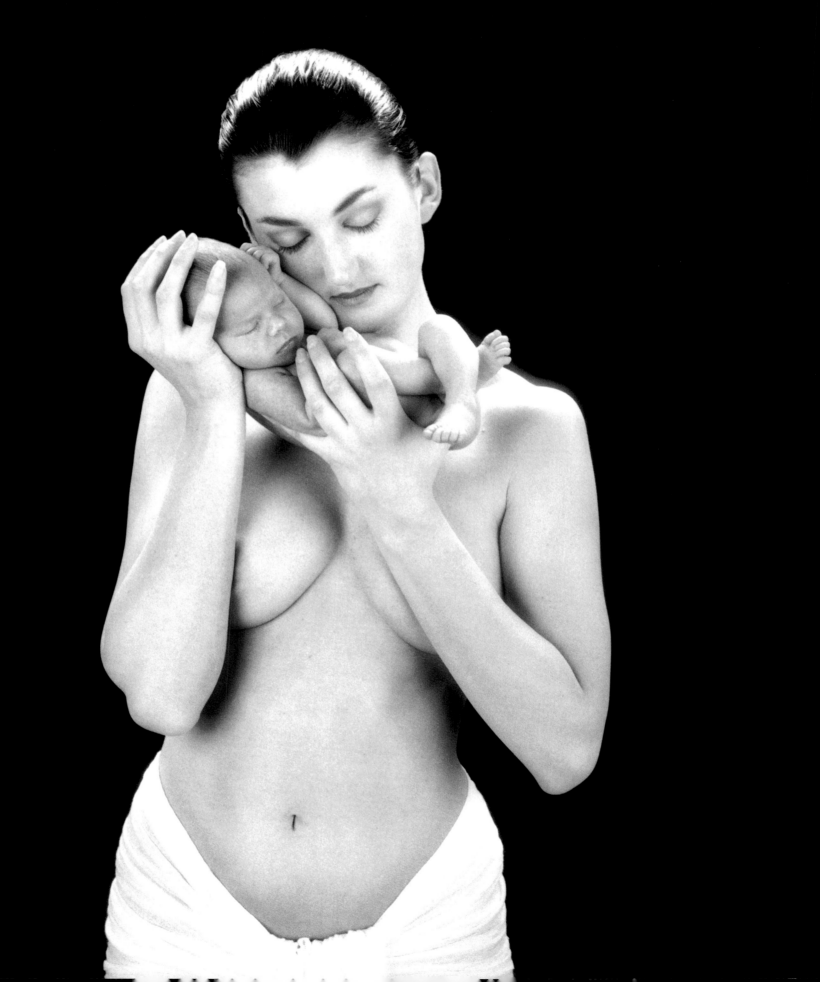

*W*hisper in your sleeping child's ear,
"I love you."

H. Jackson Brown, Jr. (1940–)

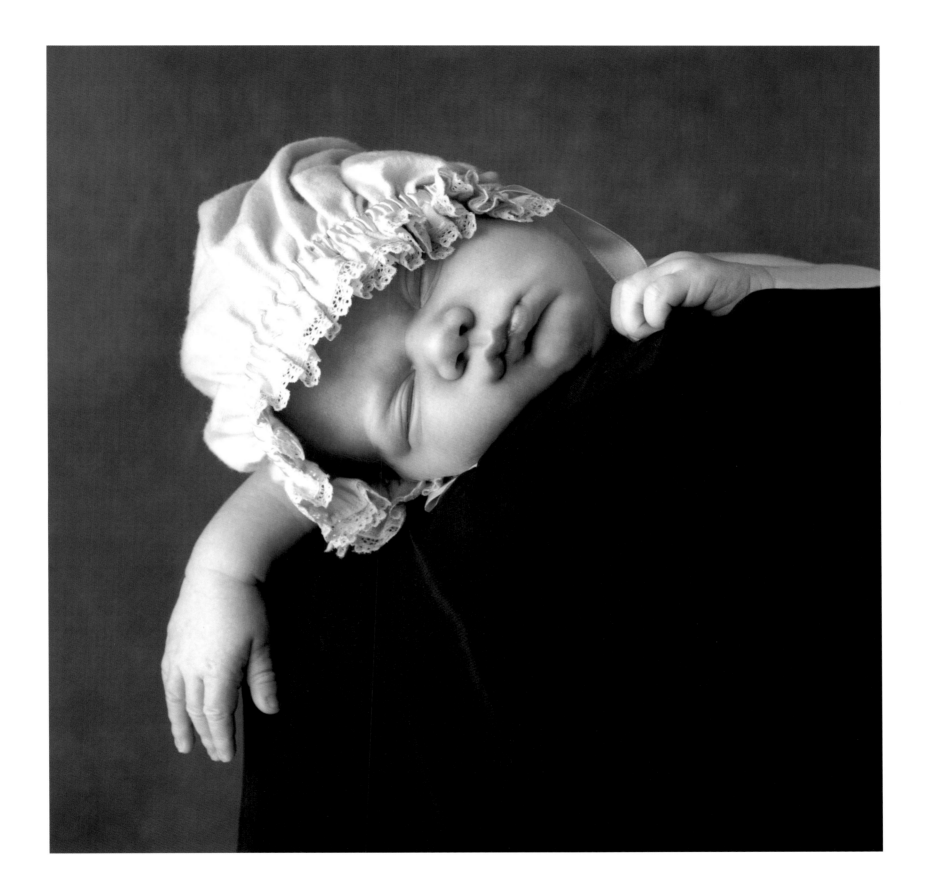

I love it – I love it – the laugh of a child,
Now rippling and gentle, now merry and wild;
Ringing out on the air with its innocent gush,
Like the trill of a bird in the twilight's soft hush;
Floating up on the breeze like the tones of a bell,
Or the music that dwells in the heart of a shell:
Oh, the laugh of a child, so wild and so free,
Is the merriest sound in the world for me!

Isabel Athelwood

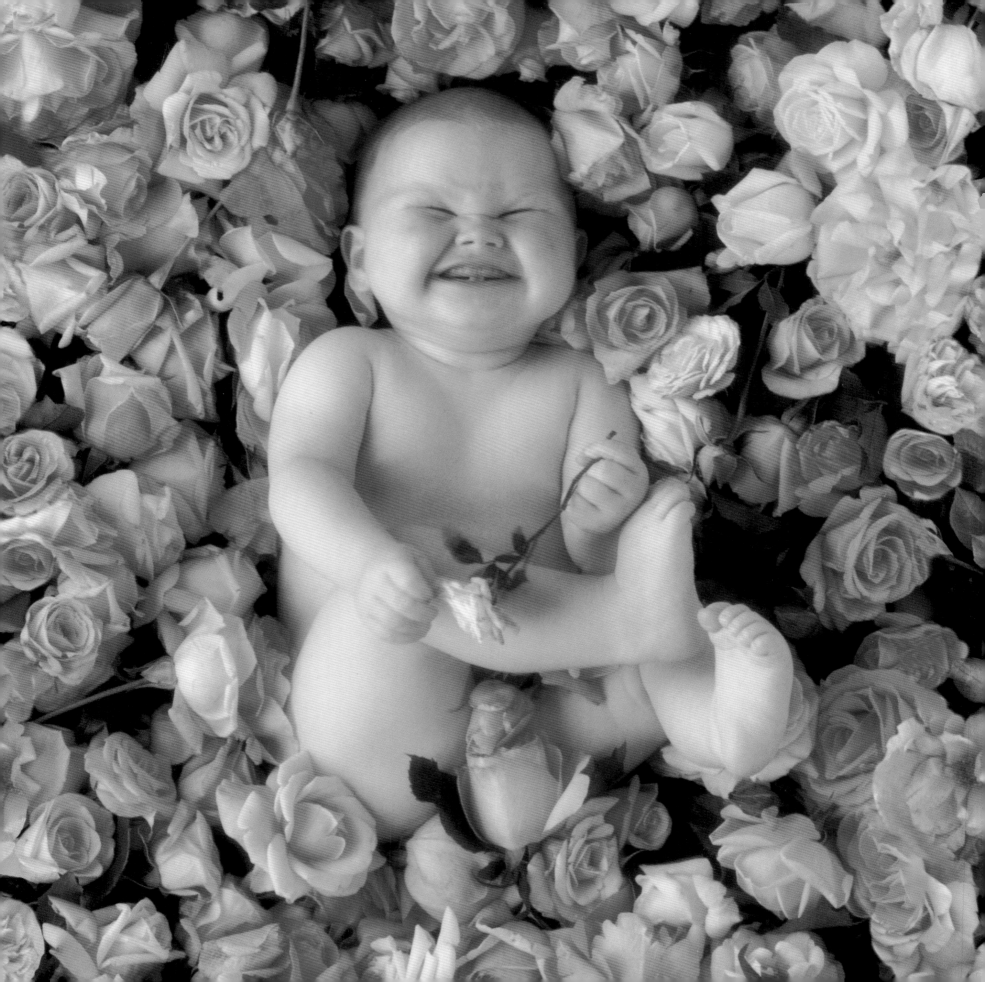

Small is beautiful.

Proverb

Each second we live is a new and unique moment
of the universe, a moment that will never be again ...

We should say to each of them: Do you know what you are? You are a marvel. You are unique. In all the years that have passed, there has never been another child like you. Your legs, your arms, your clever fingers, the way you move.

You may become a Shakespeare, a Michelangelo, a Beethoven ...

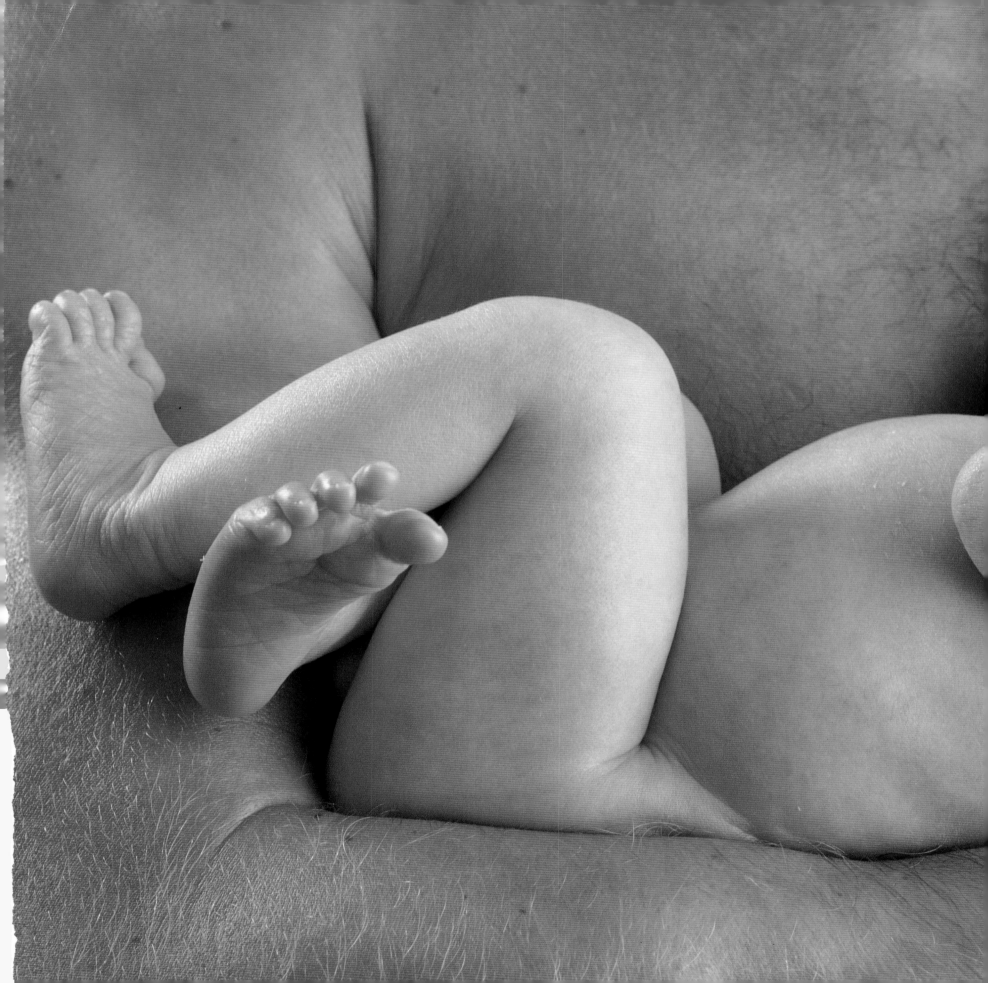

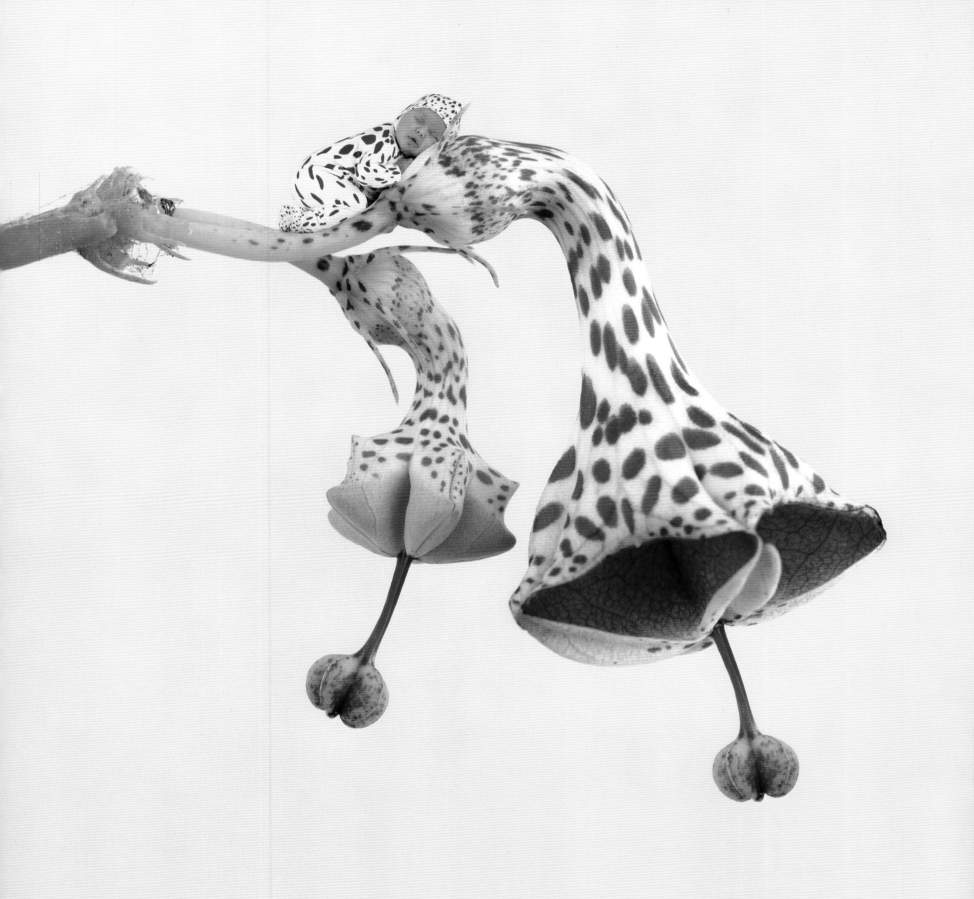

And what do we teach our children? We teach them that
two and two make four, and that Paris is the capital of France.
When will we also teach them what they are? ...

\mathcal{Y}ou have the capacity for anything.
Yes, you are a marvel. And when you grow up,
can you then harm another who is, like you, a marvel?

You must work – we must all work – to make the world worthy of its children.

Pablo Casals (1876–1973)

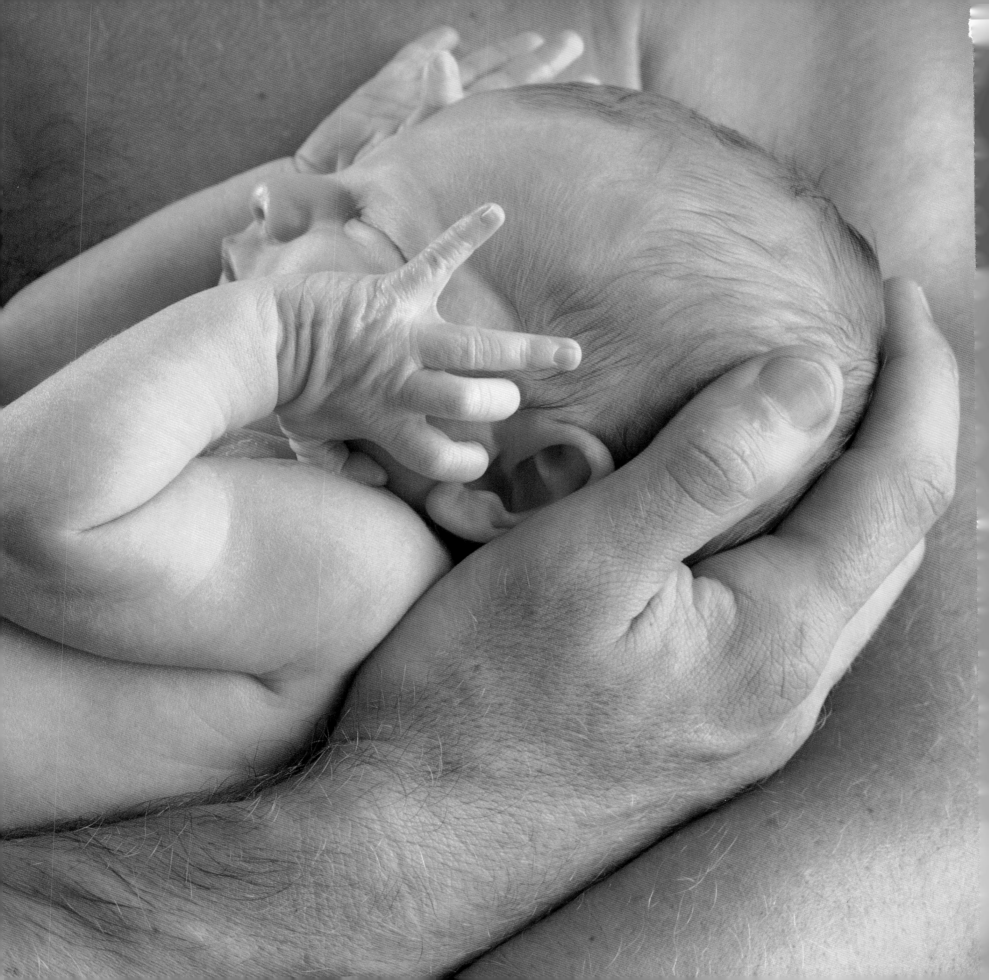

From small beginnings come great things.

Proverb

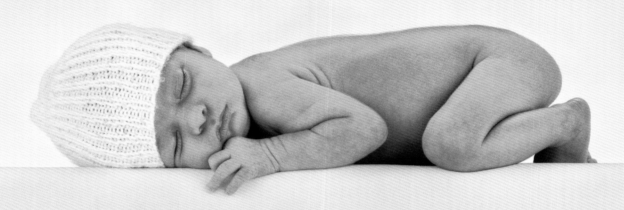

*L*ife itself is the most wonderful fairy tale.

Hans Christian Andersen (1805–1875)

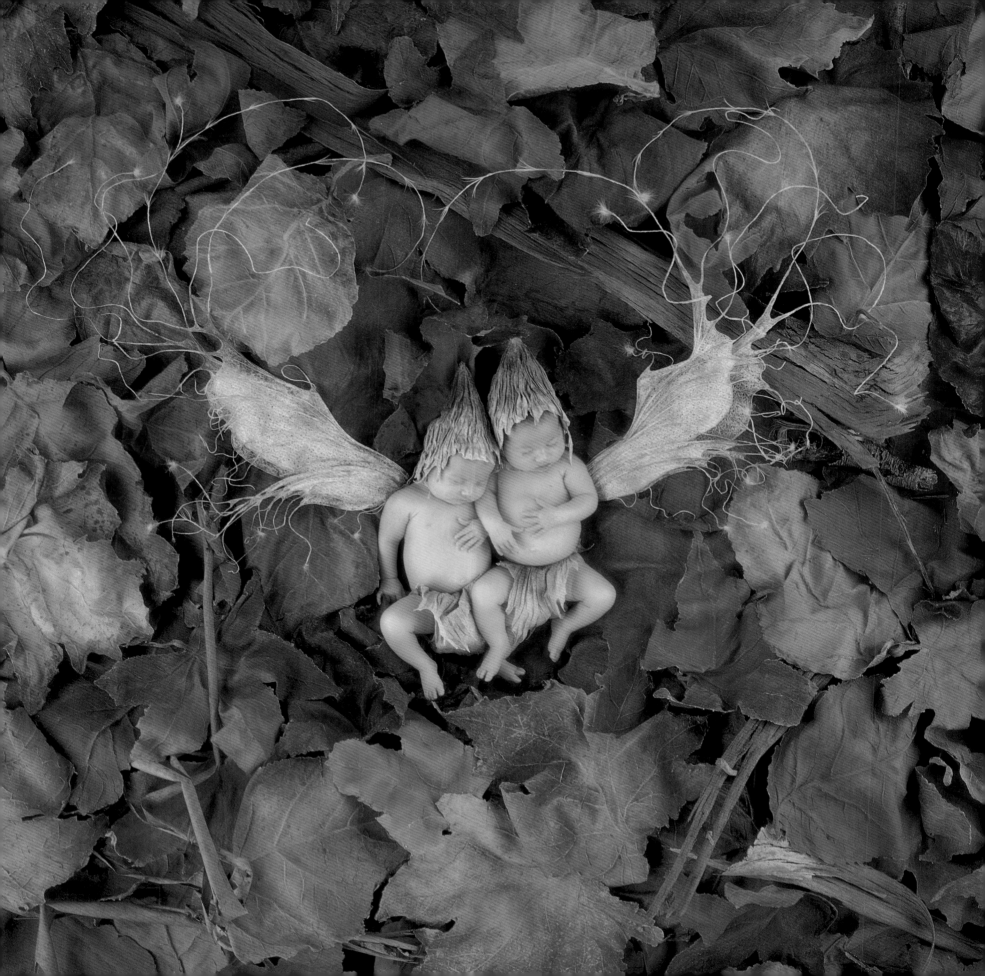

Each day I love you more ...
today, more than yesterday ...
and less than tomorrow.

Rosemonde Gérard

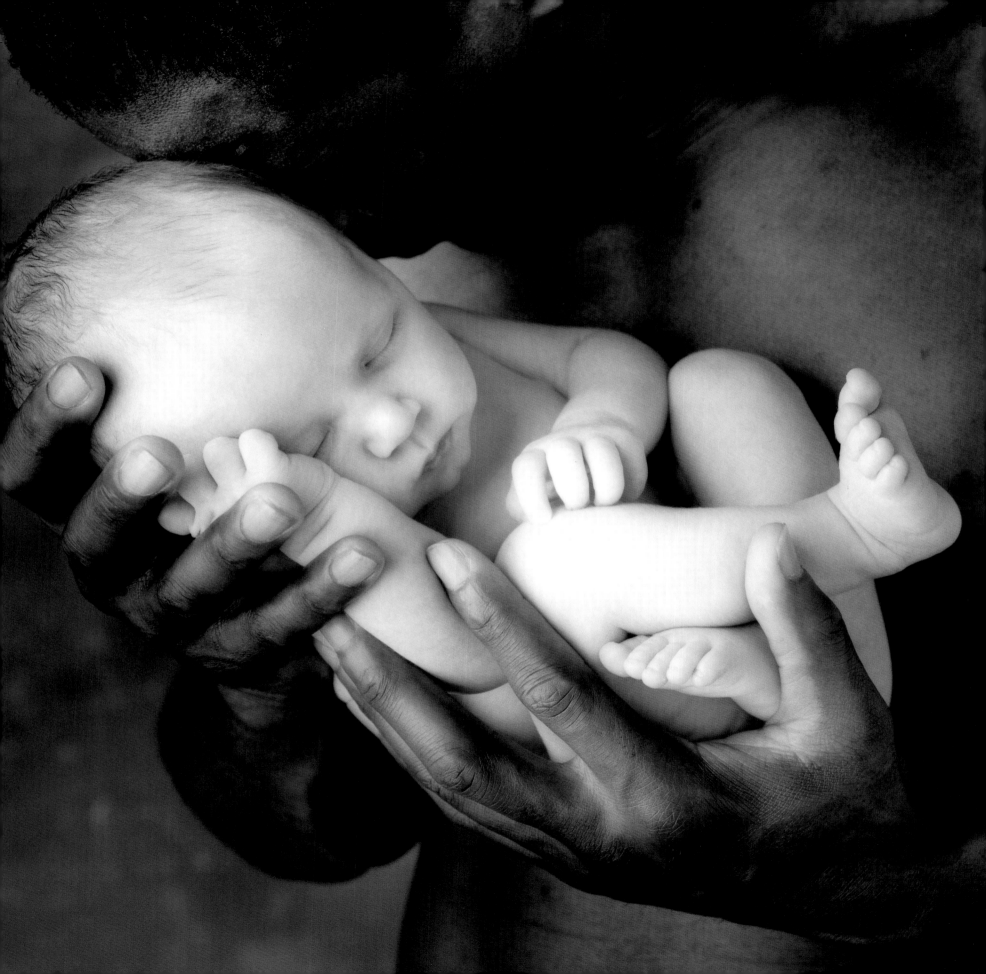

\mathcal{T}he smiles of infants are said to be the first fruits of human reason.

Rev. Henry N. Hudson

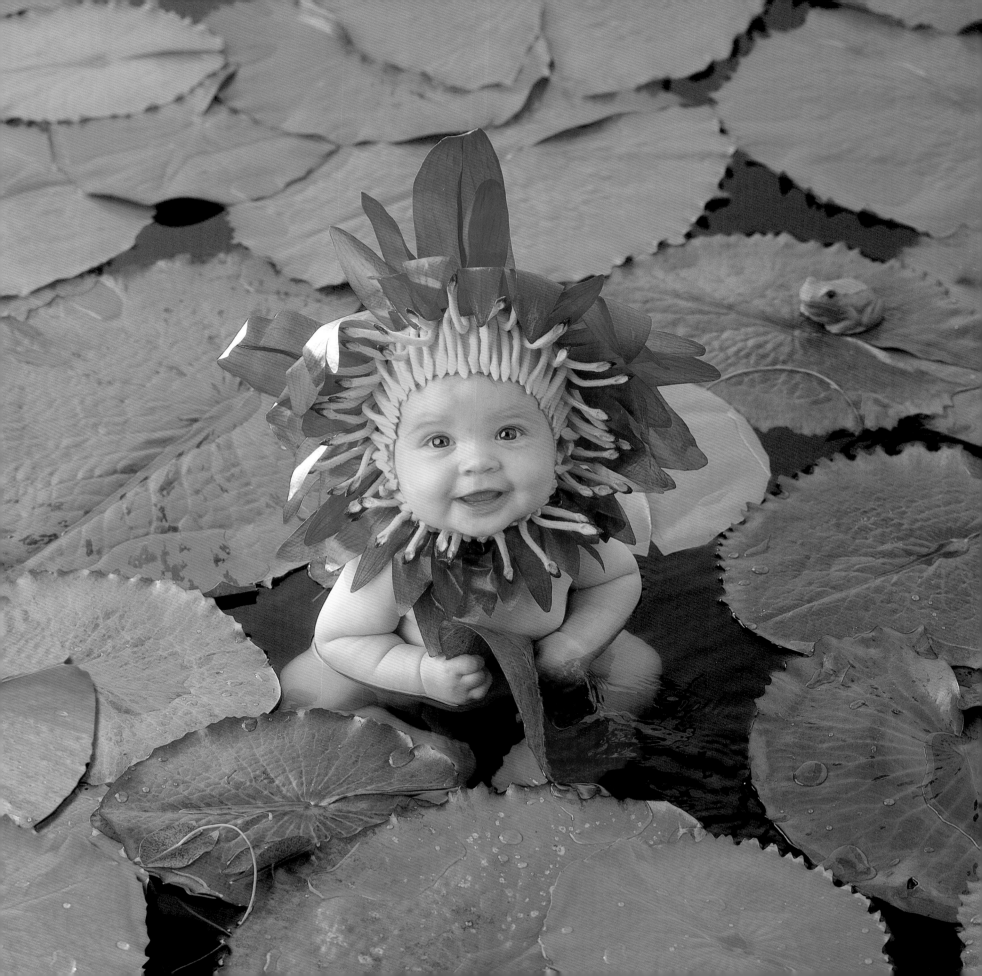

You should have a softer pillow than my heart.

Lord Byron (1788–1824)

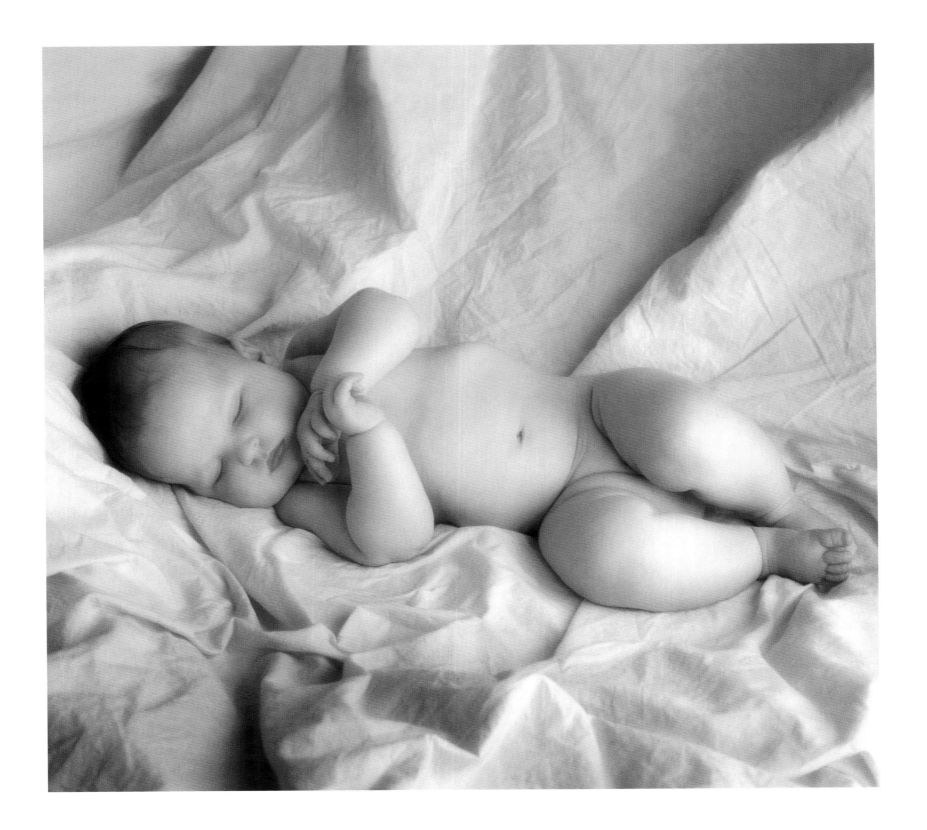

What's in a name?
That which we call a rose
By any other name would smell as sweet.

William Shakespeare (1564–1616)

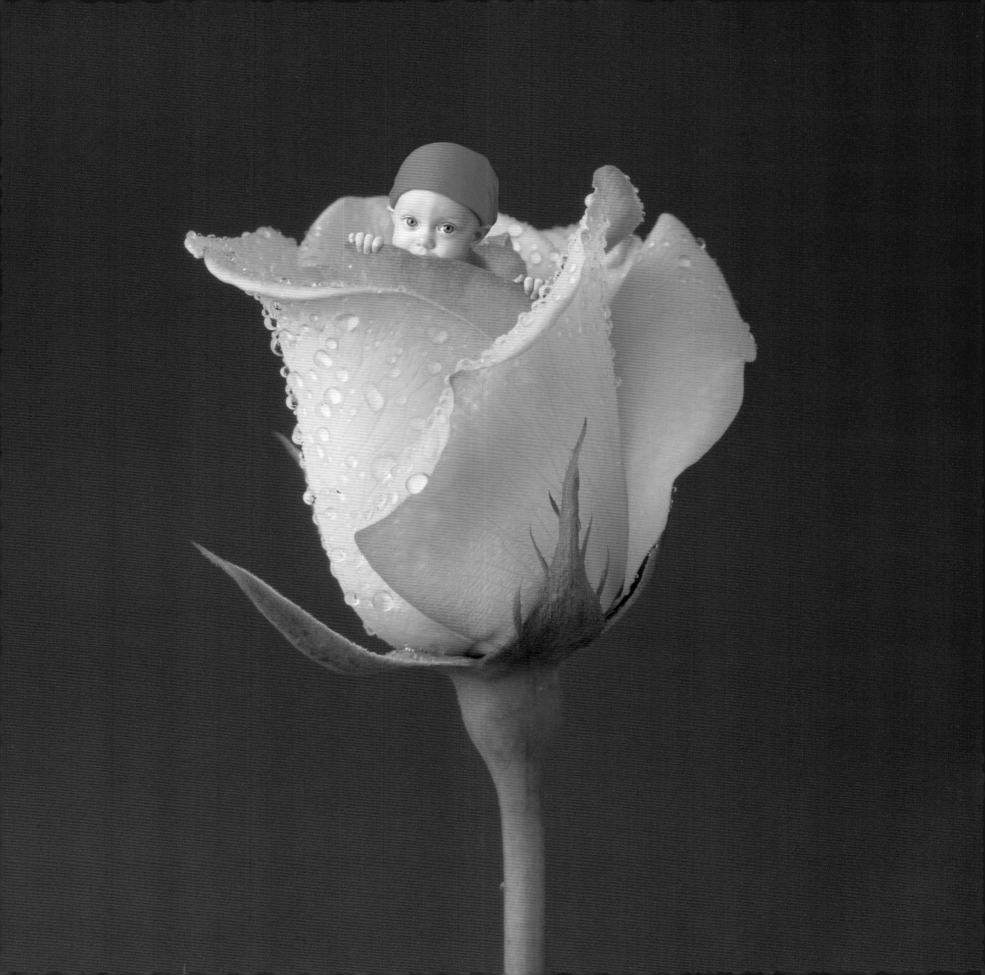

The greatest gift is a portion of thyself.

Ralph Waldo Emerson (1803–1882)

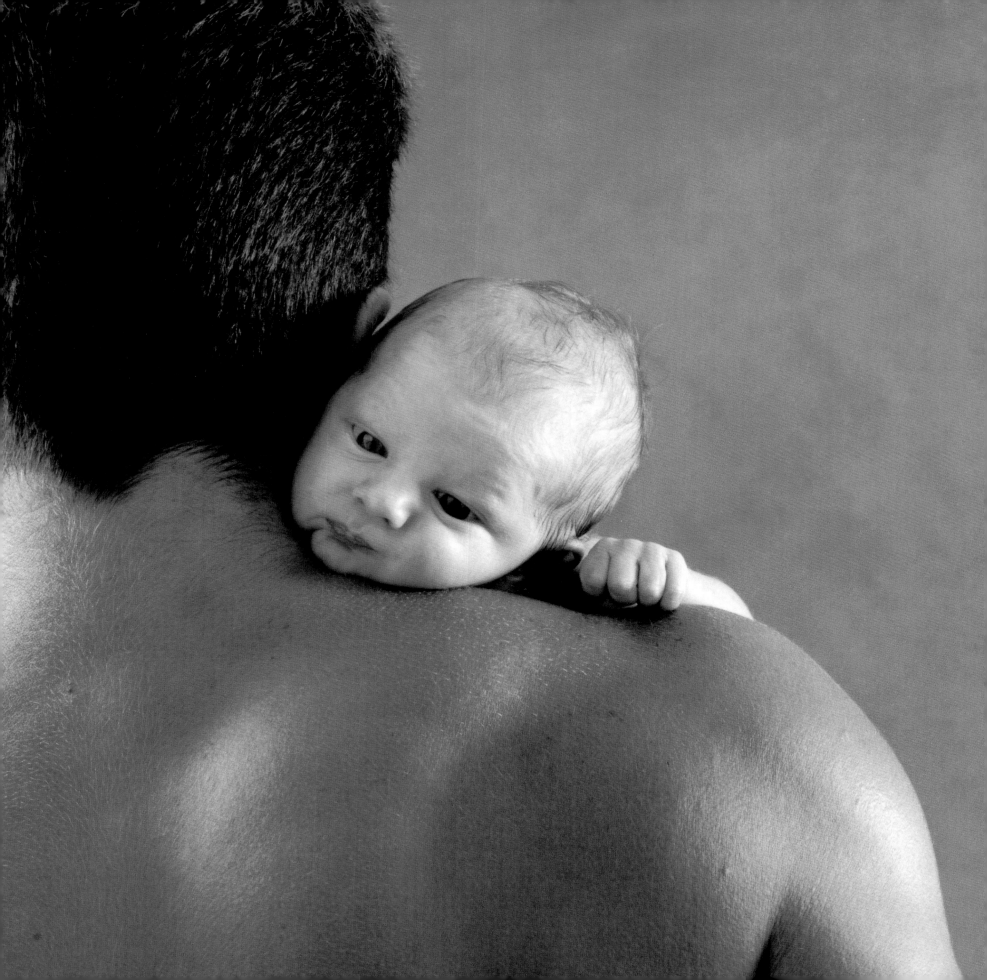

O wonderful, wonderful,
and most wonderful wonderful!
and yet again wonderful.

William Shakespeare (1564–1616)

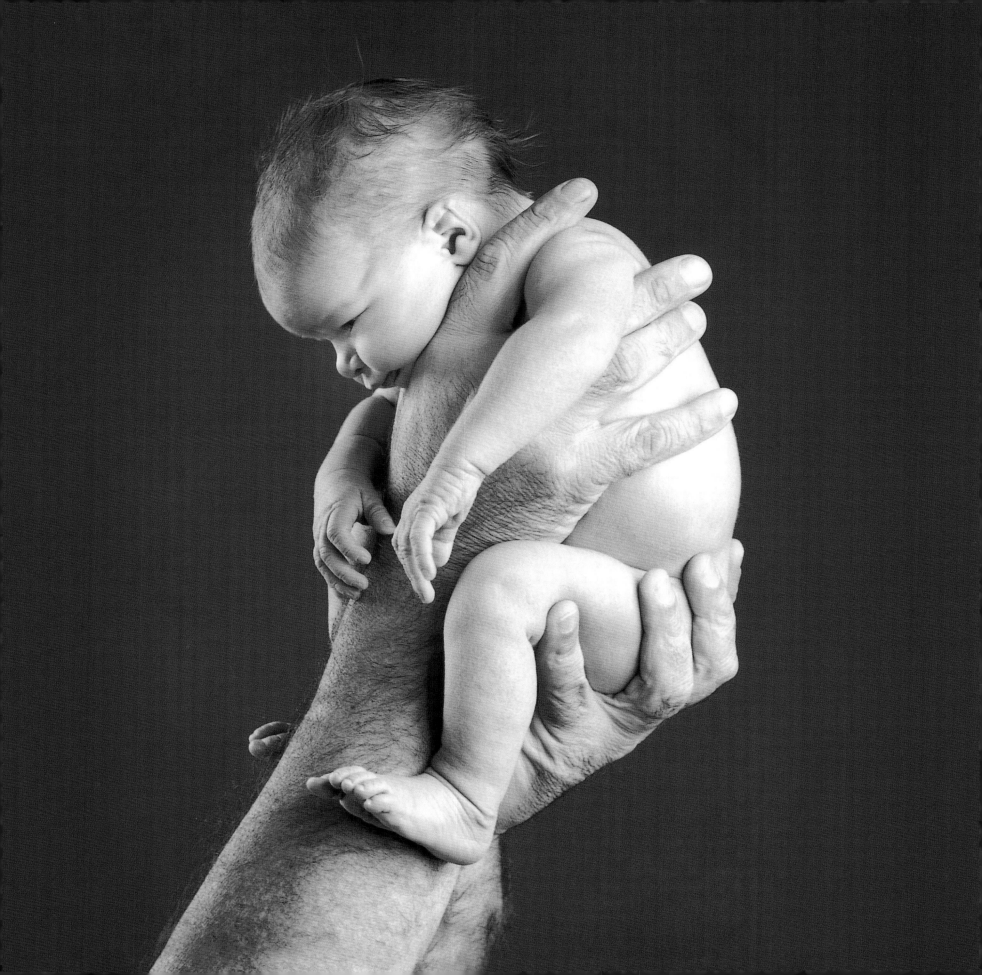

Happiness is as a butterfly which,
when pursued, is always beyond our grasp,
but which, if you will sit down quietly,
may alight upon you.

Nathaniel Hawthorne (1804–1864)

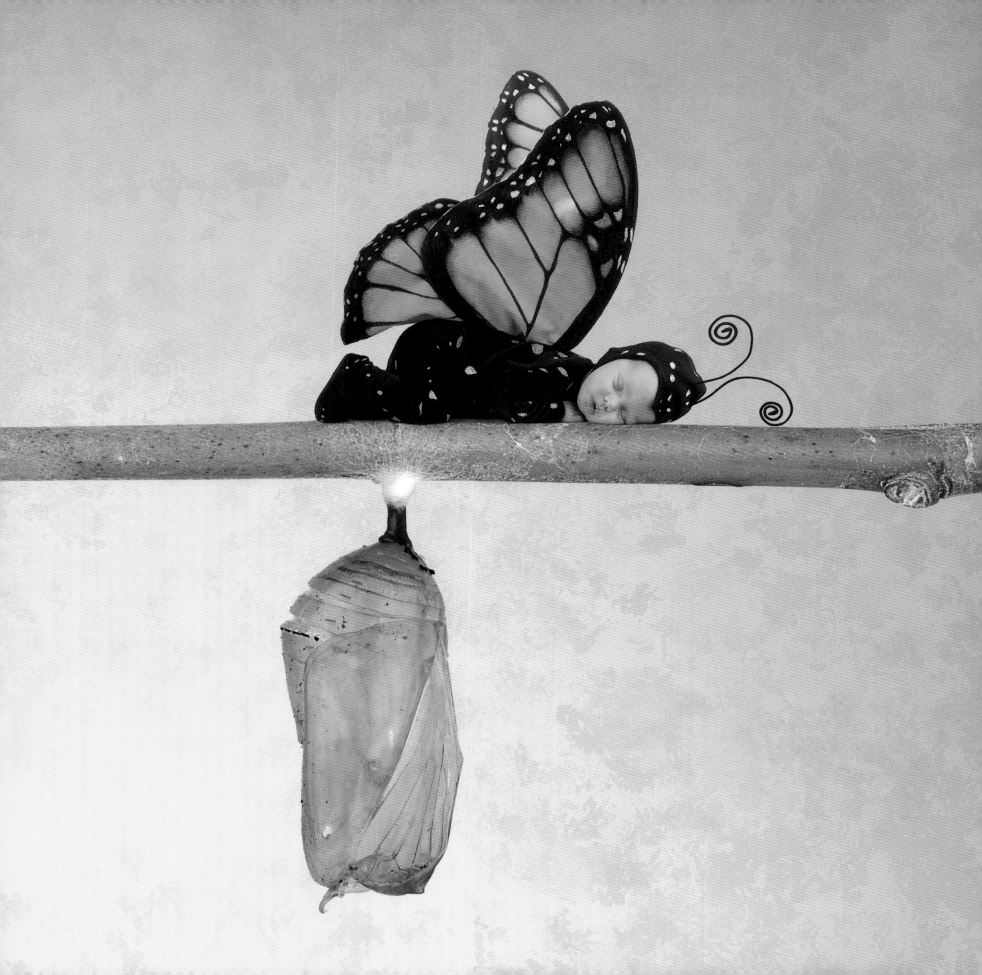

Those who bring sunshine
to the lives of others
cannot keep it from themselves.

J. M. Barrie (1860–1937)

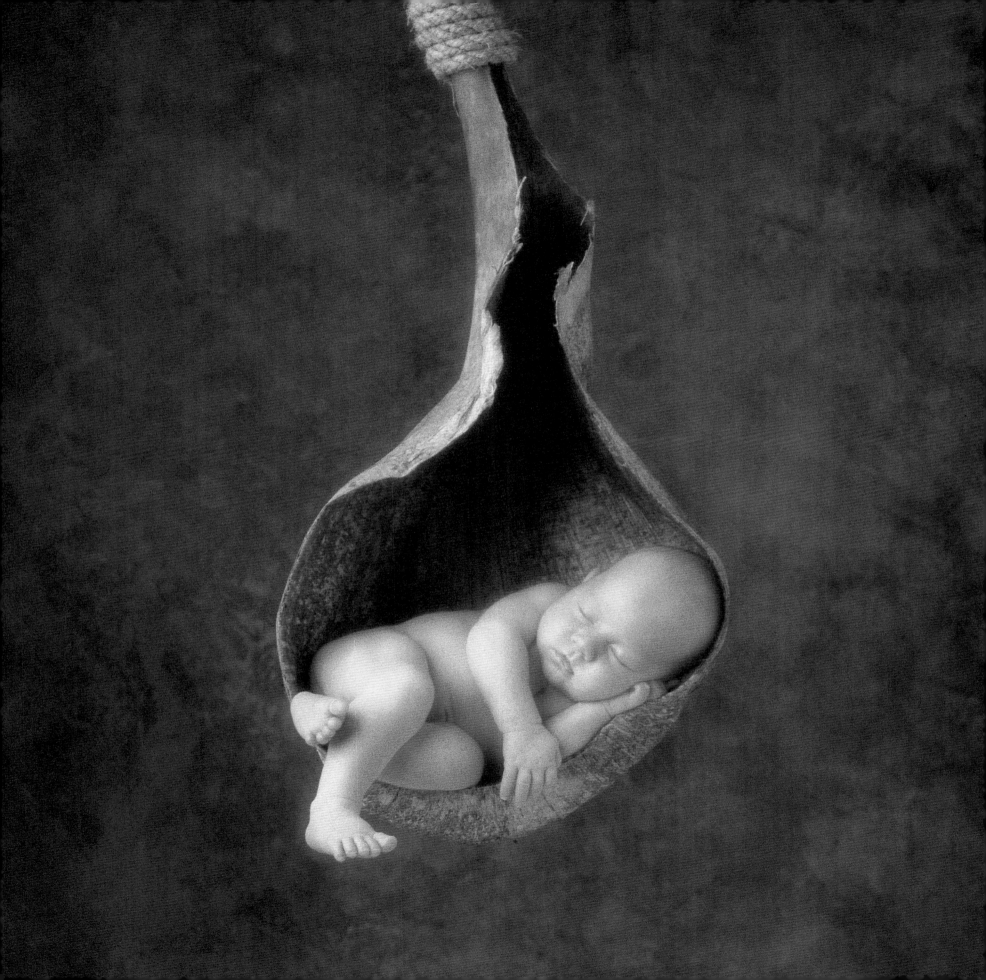

Angels can fly
because they take themselves lightly.

G. K. Chesterton (1874–1936)

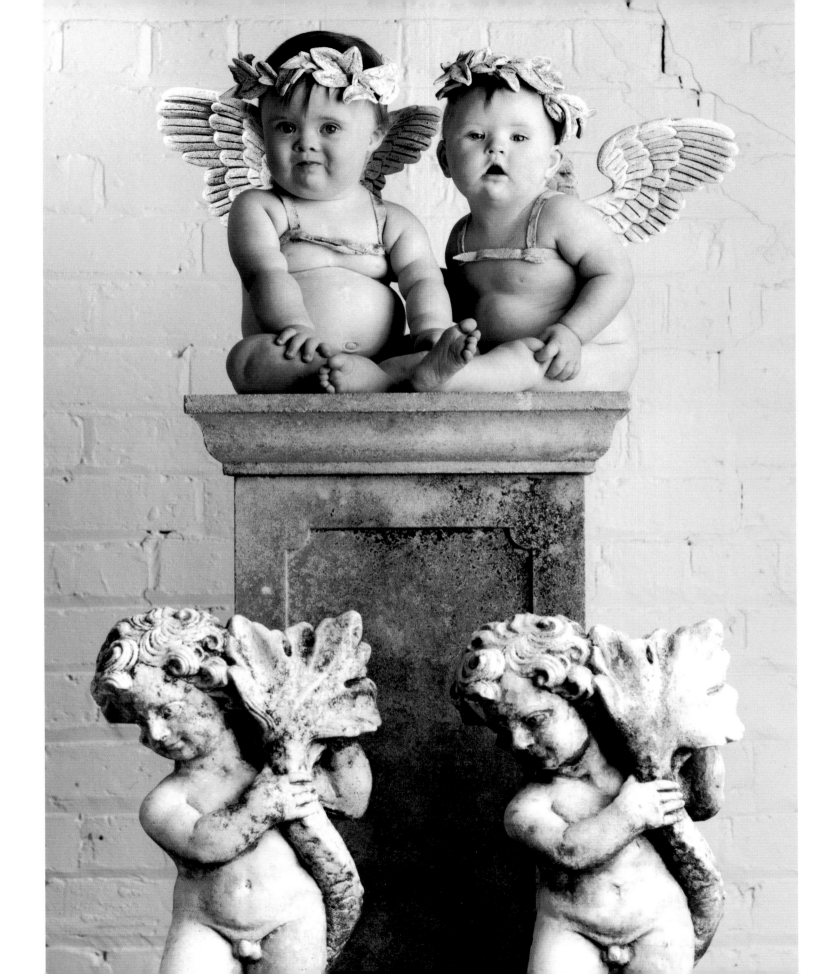

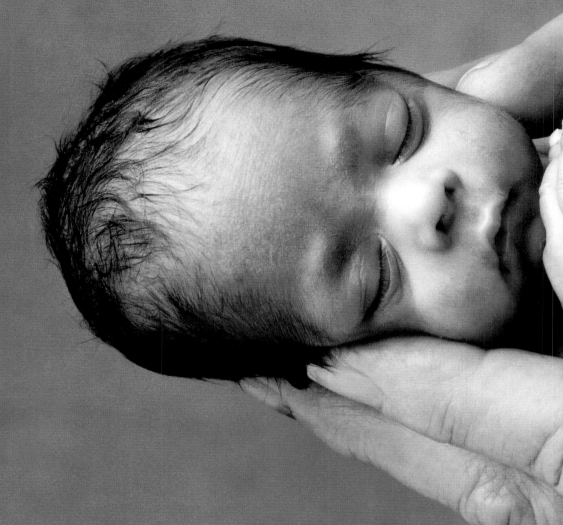

There are two ways to live your life.
One is as though nothing is a miracle.
The other is as though everything is a miracle.

Albert Einstein (1879–1955)

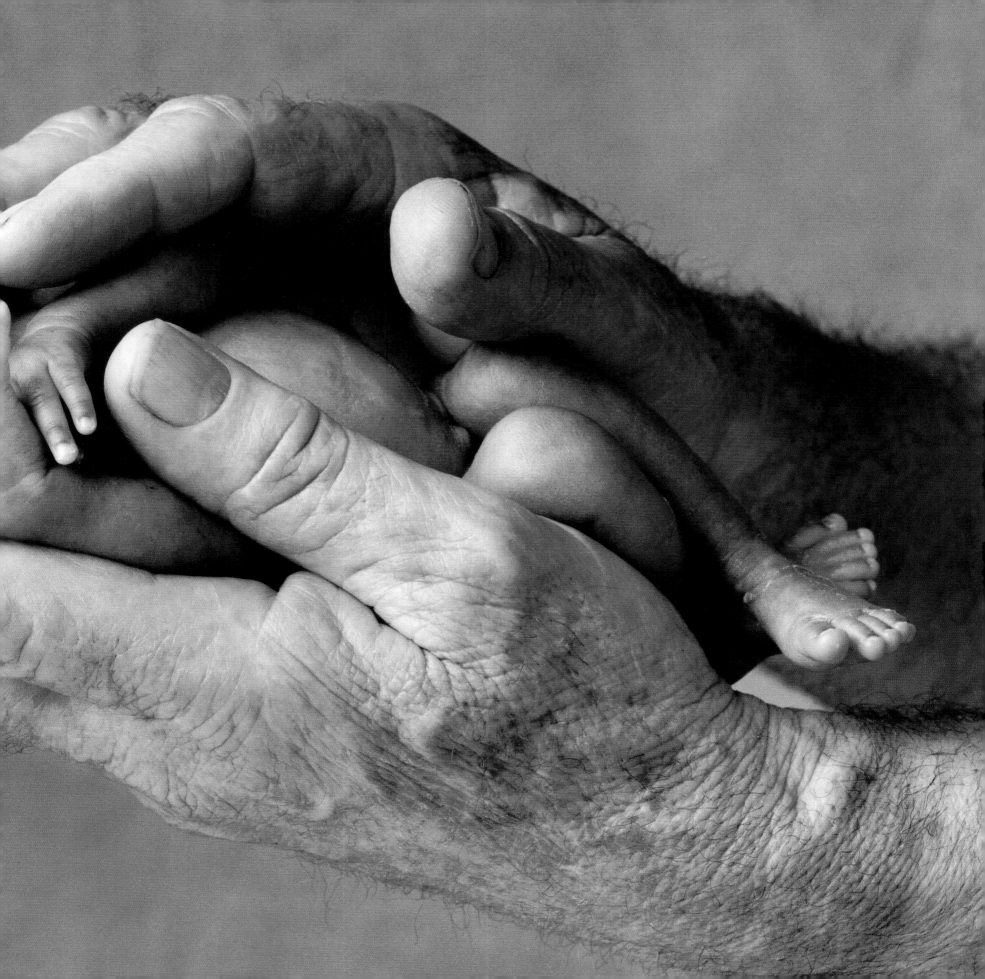

Little drops of water, little grains of sand,
Make the mighty ocean and the pleasant land.
And the little moments, humble though they be,
Make the mighty ages of Eternity.

Julia A. Carney (1823–1908)

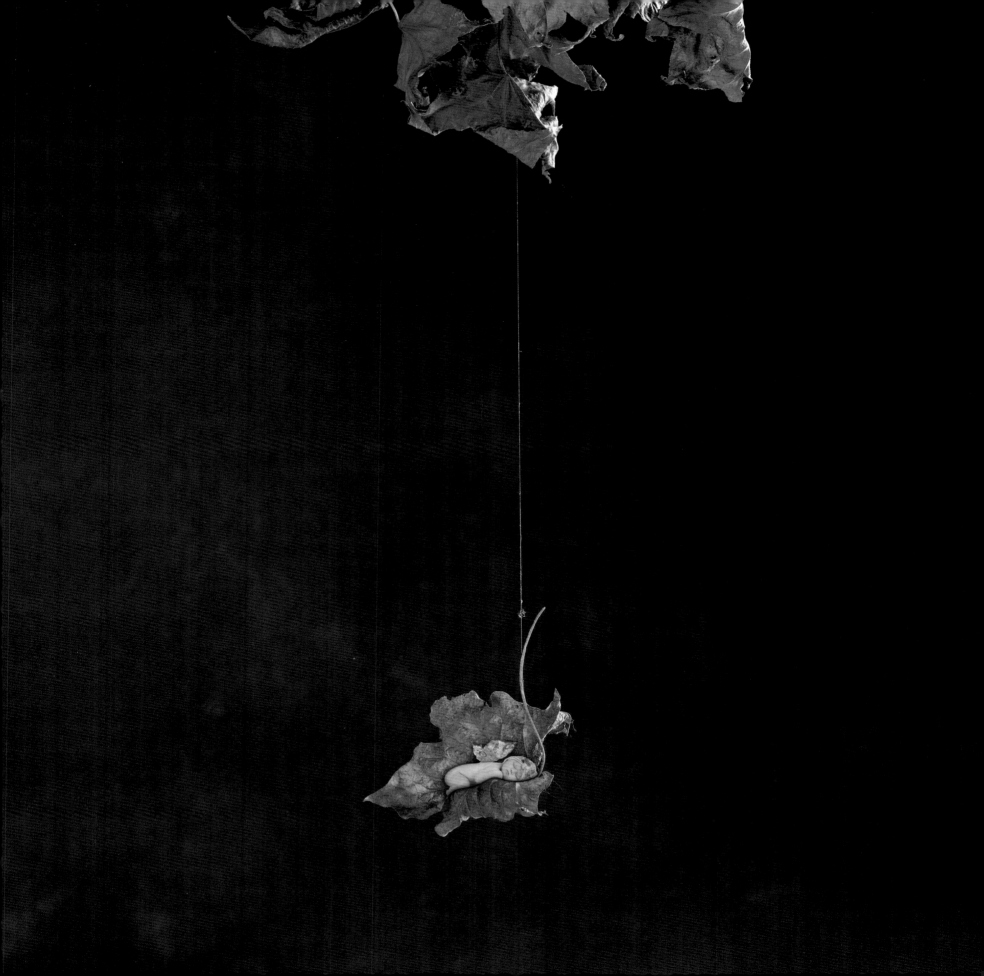

*I*t was the Rainbow gave thee birth,
And left thee all her lovely hues.

William Henry Davies (1871–1940)

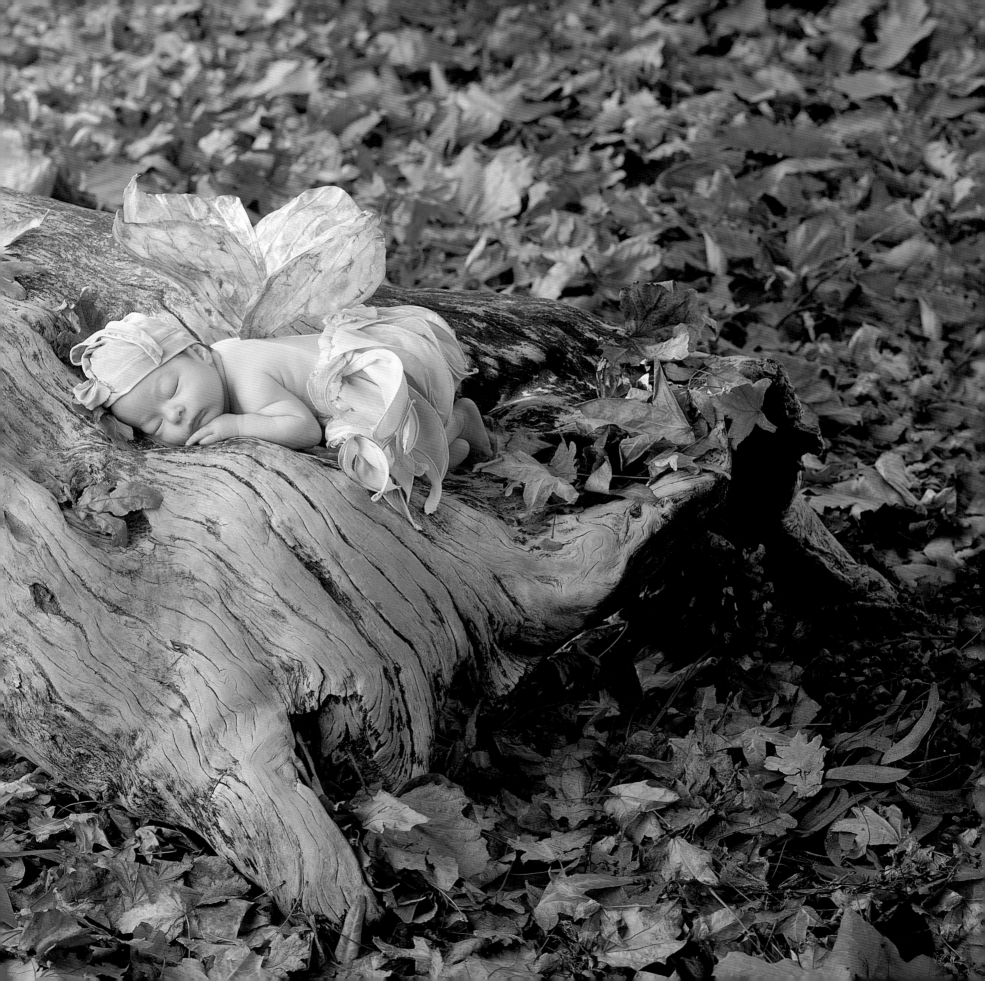

I have spread my dreams under your feet;
Tread softly because you tread on my dreams.

W. B. Yeats (1865–1939)

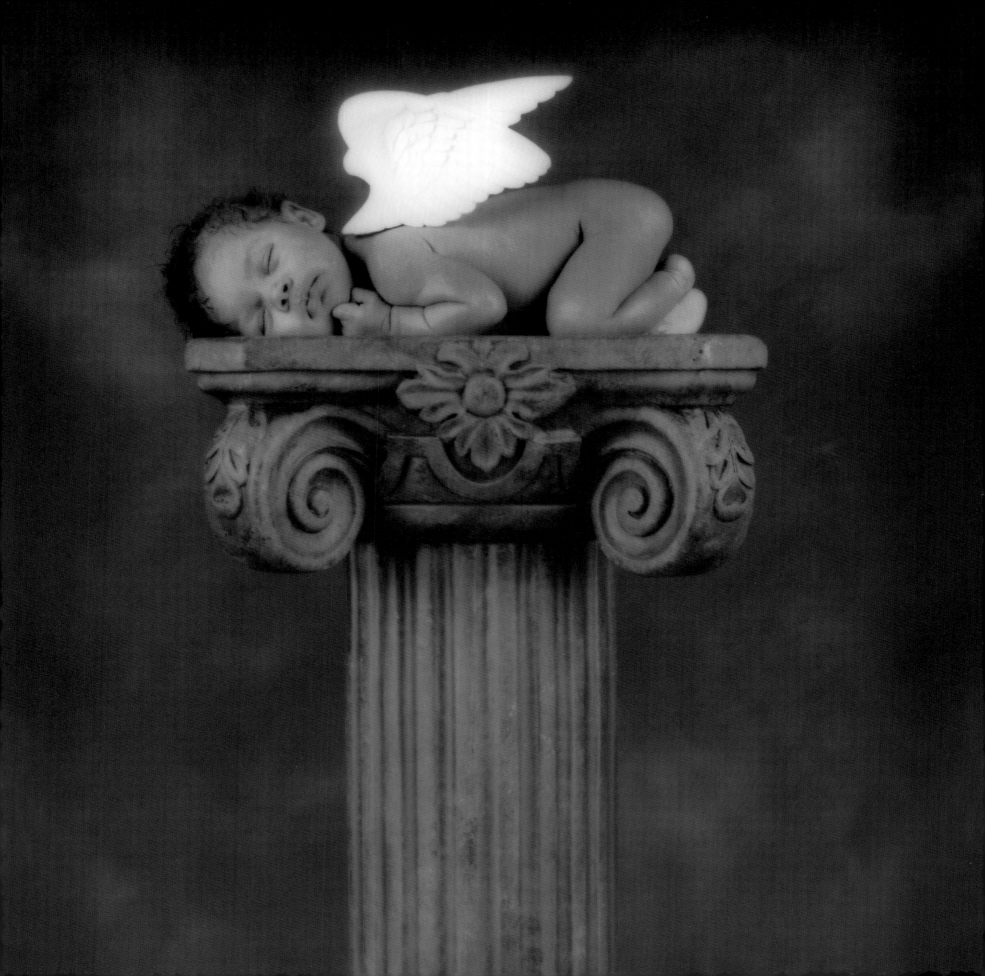

Oh! little lock of golden hue,
In gently waving ringlet curl'd,
By the dear head on which you grew,
I would not lose you for a world.

Lord Byron (1788–1824)

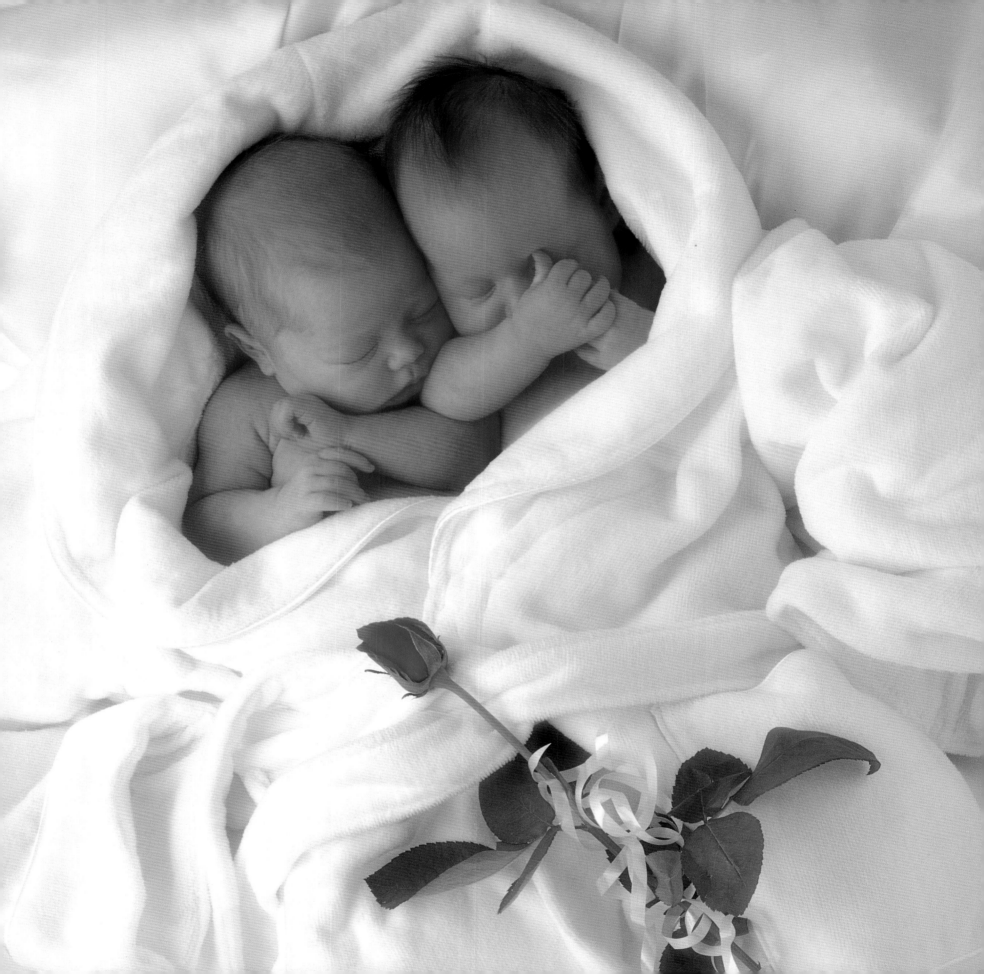

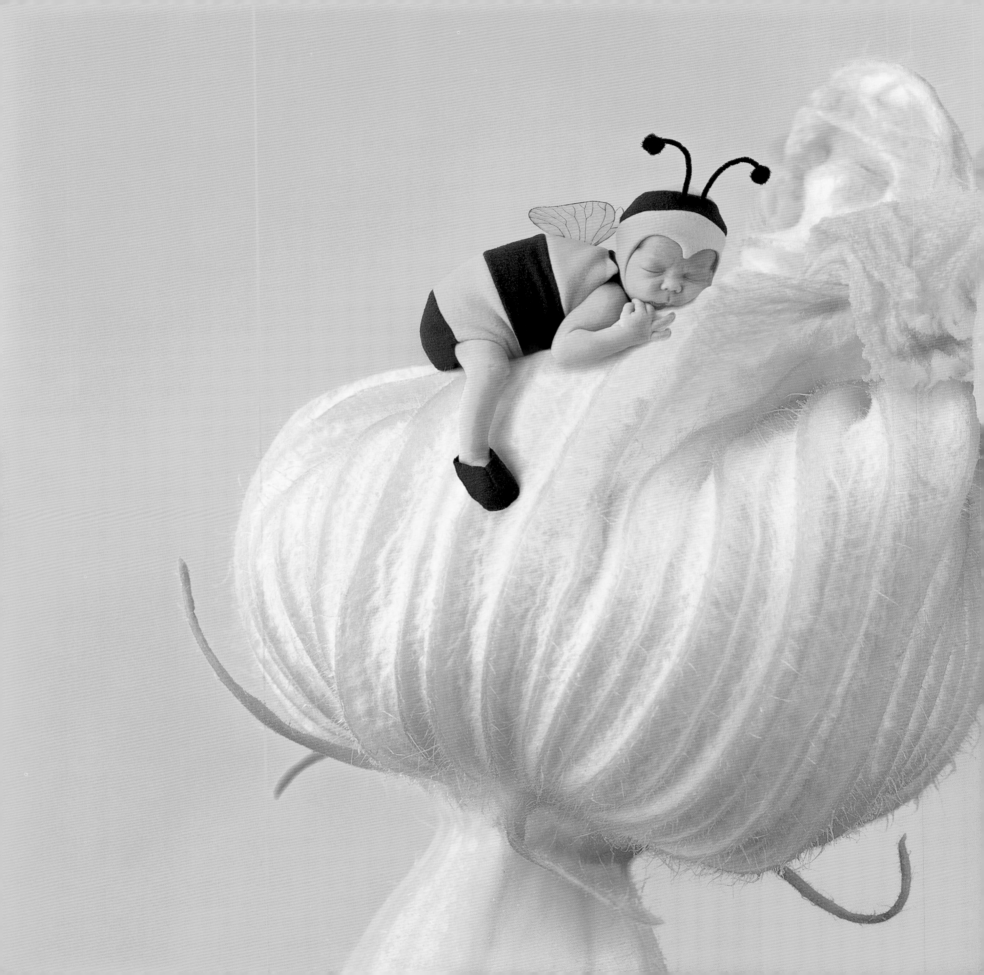

*Happiness is the intoxication produced by the moment of poise
between a satisfactory past, and an immediate future,
rich with promise.*

Ella Maillart (1903–)

*B*abies are such a nice way to start people.

Don Herold (1889–1966)

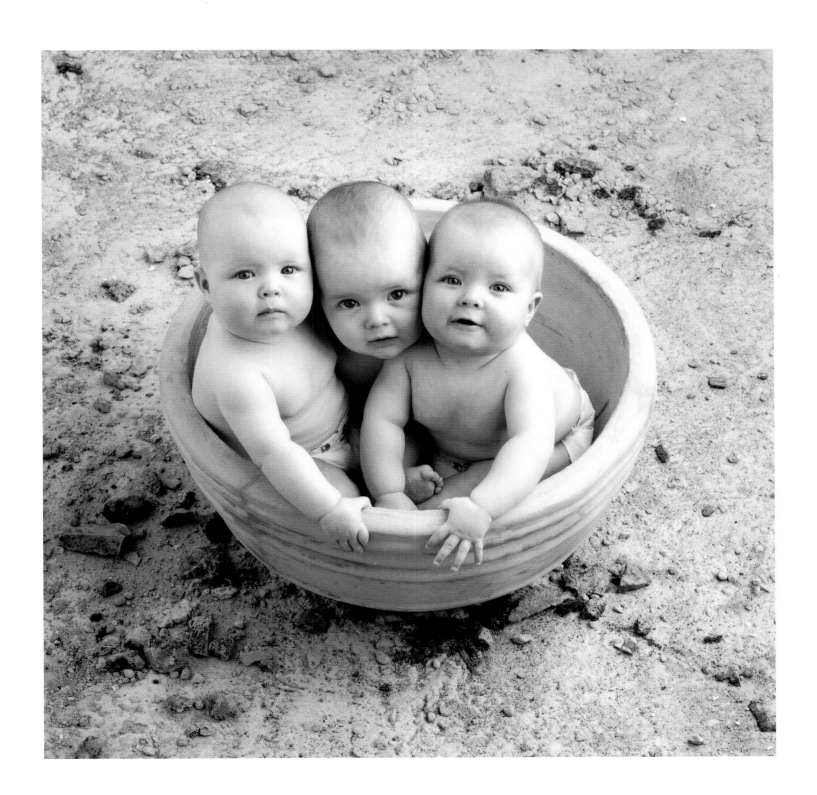

Children in a family
are like flowers in a bouquet:
there's always one determined to face
in an opposite direction
from the way the arranger desires.

Marcelene Cox

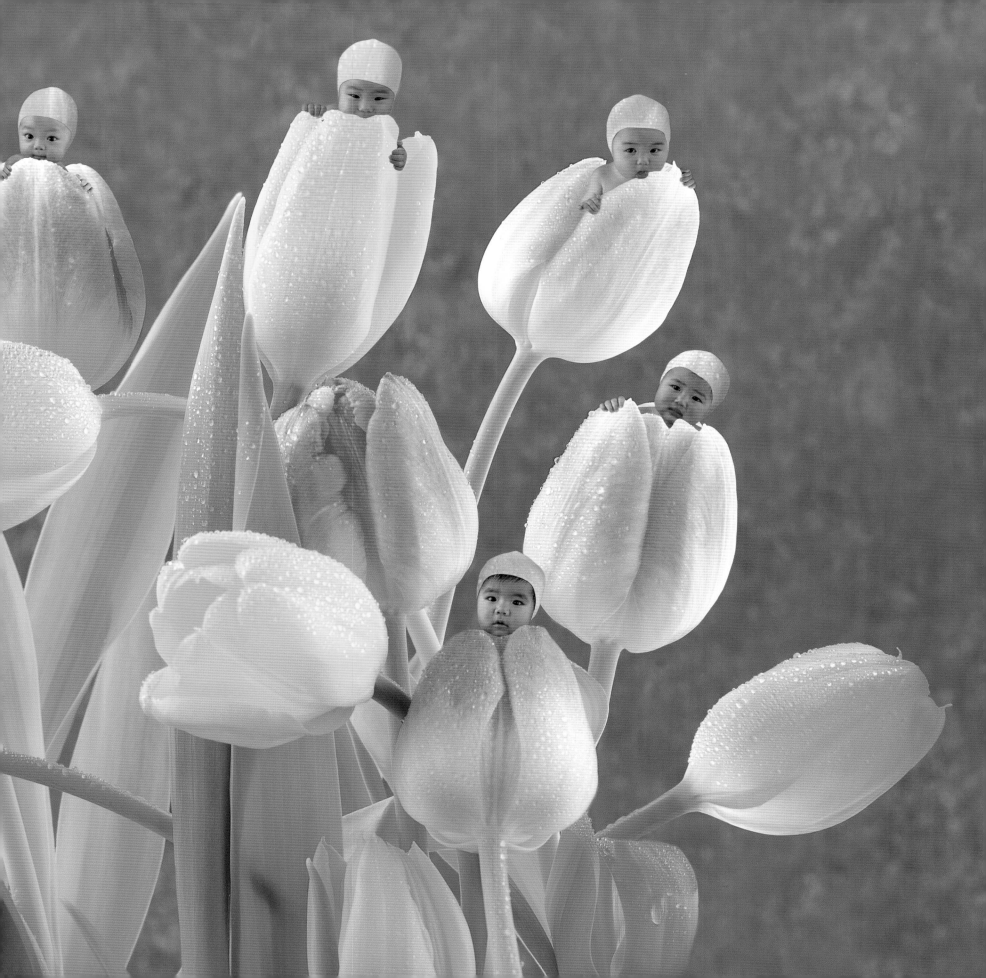

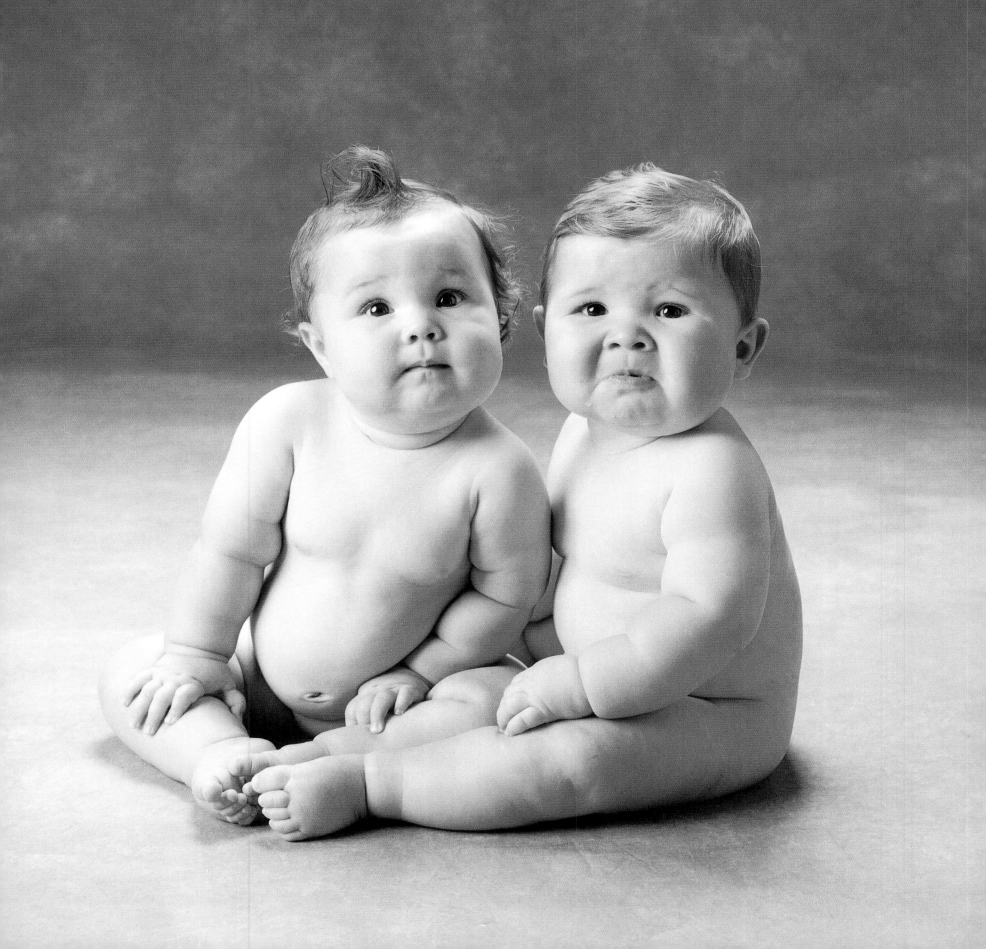

*W*hen you havva no babies –
you havva nothing.

Italian immigrant woman

A perfect example of minority rule
is a baby in the house.

Anonymous

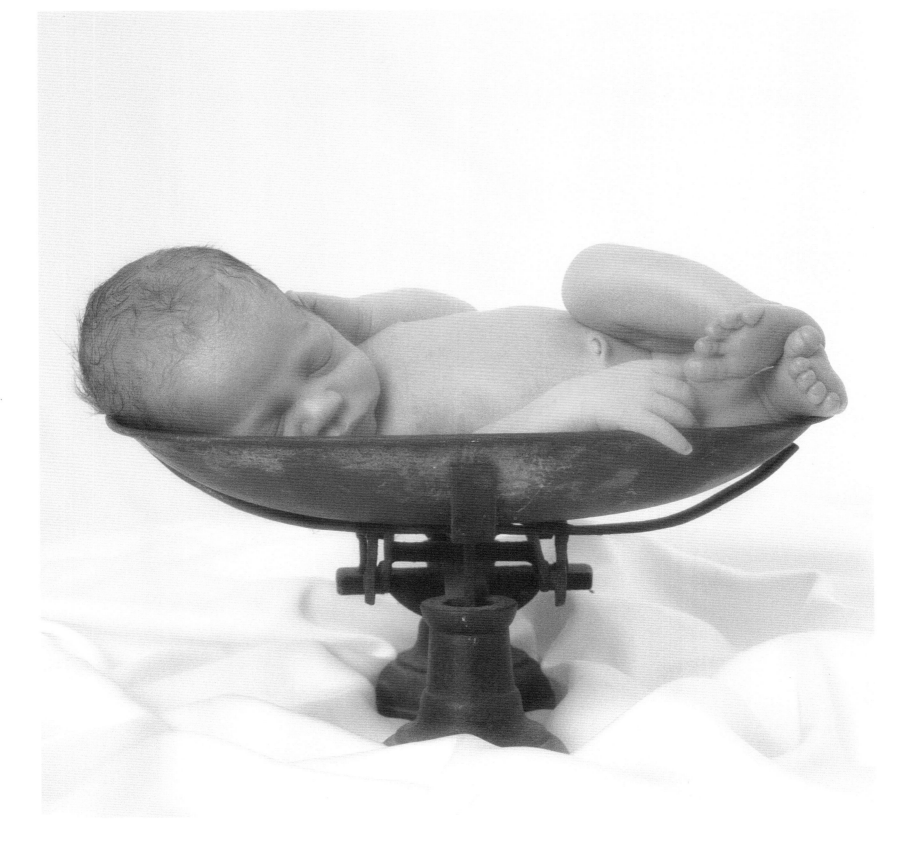

The fragrance always stays in the hand
that give the rose.

Hada Bejar

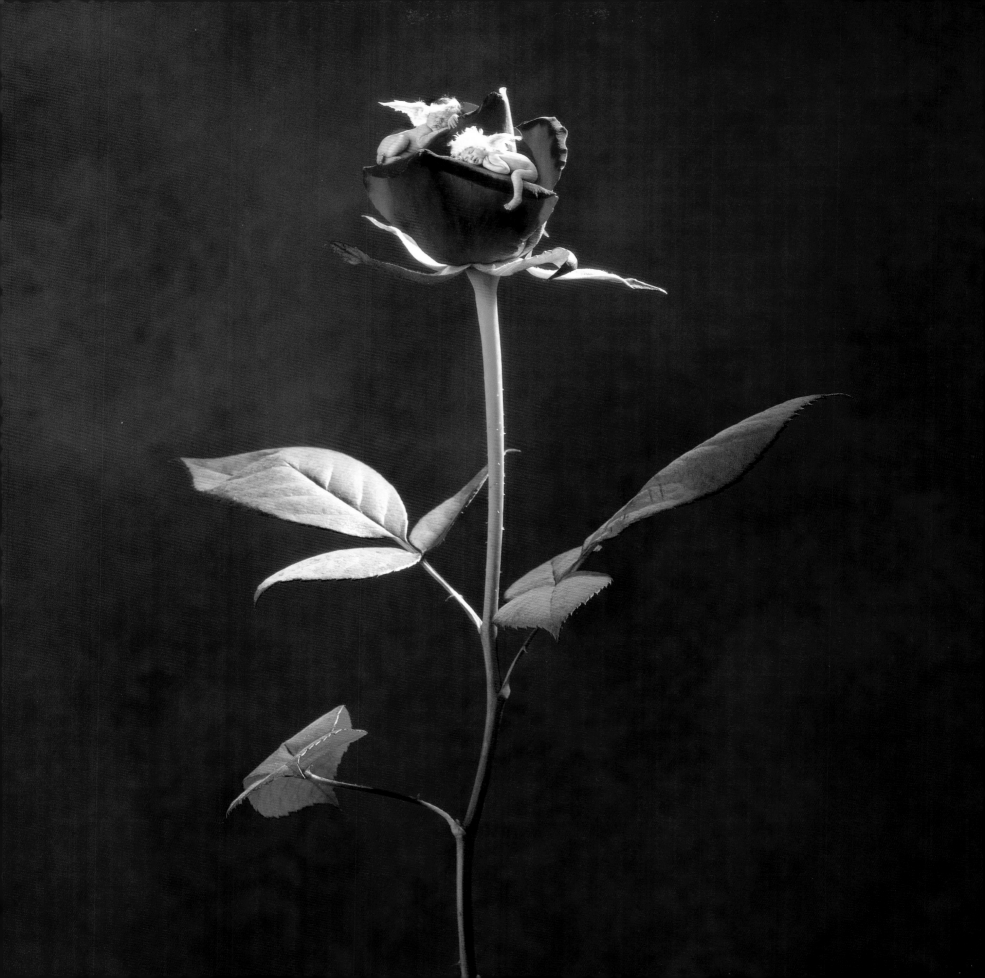

Golden slumbers kiss your eyes,
Smiles awake you when you rise:
Sleep, pretty darling, do not cry,
And I will sing a lullaby.

Thomas Dekker (1570?–1632)

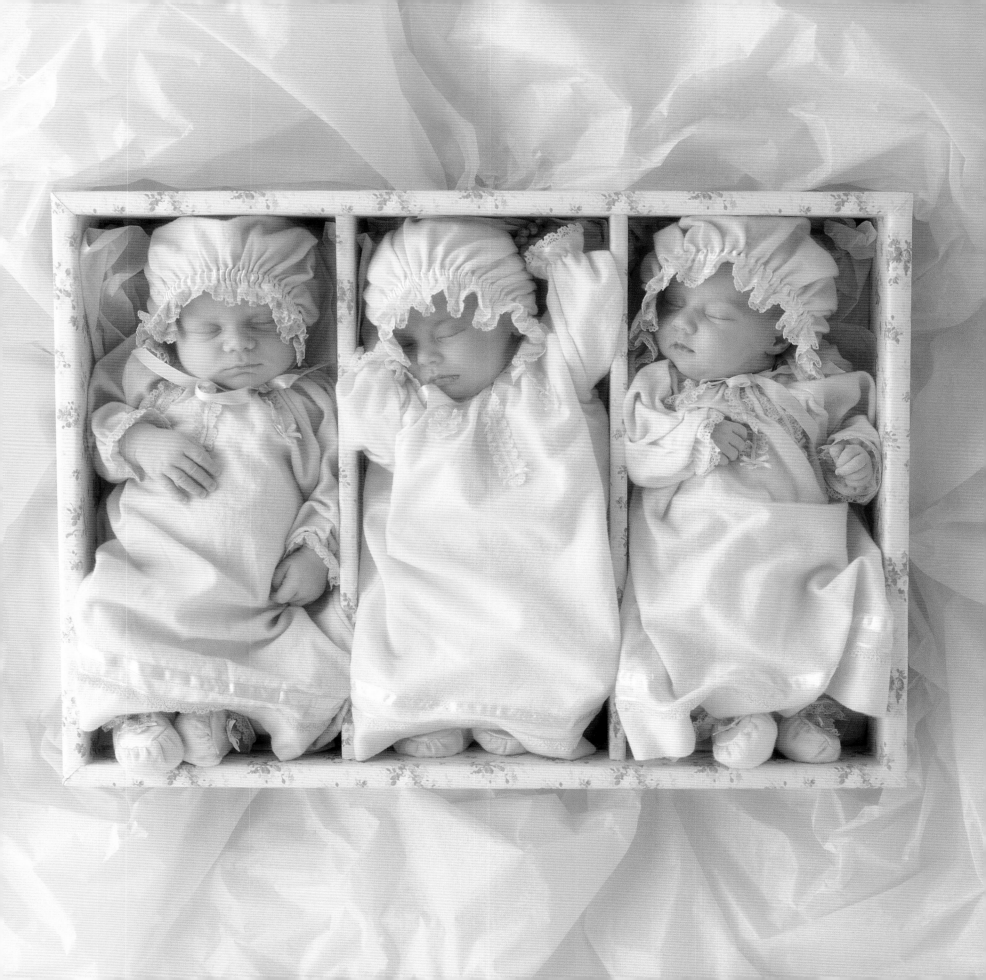

You too, my mother, read my rhymes
For love of unforgotten times,
And you may chance to hear once more
The little feet along the floor.

Robert Louis Stevenson (1850–1894)

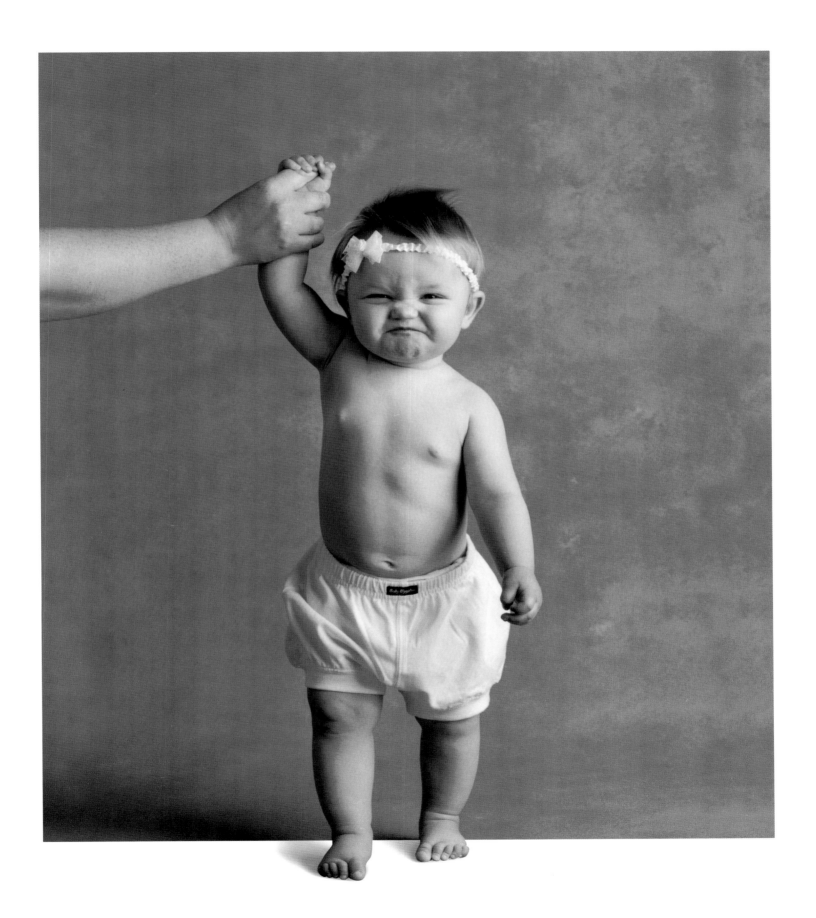

*T*he decision to have a child
is to accept that your heart will forever walk about
outside of your body.

Katherine Hadley

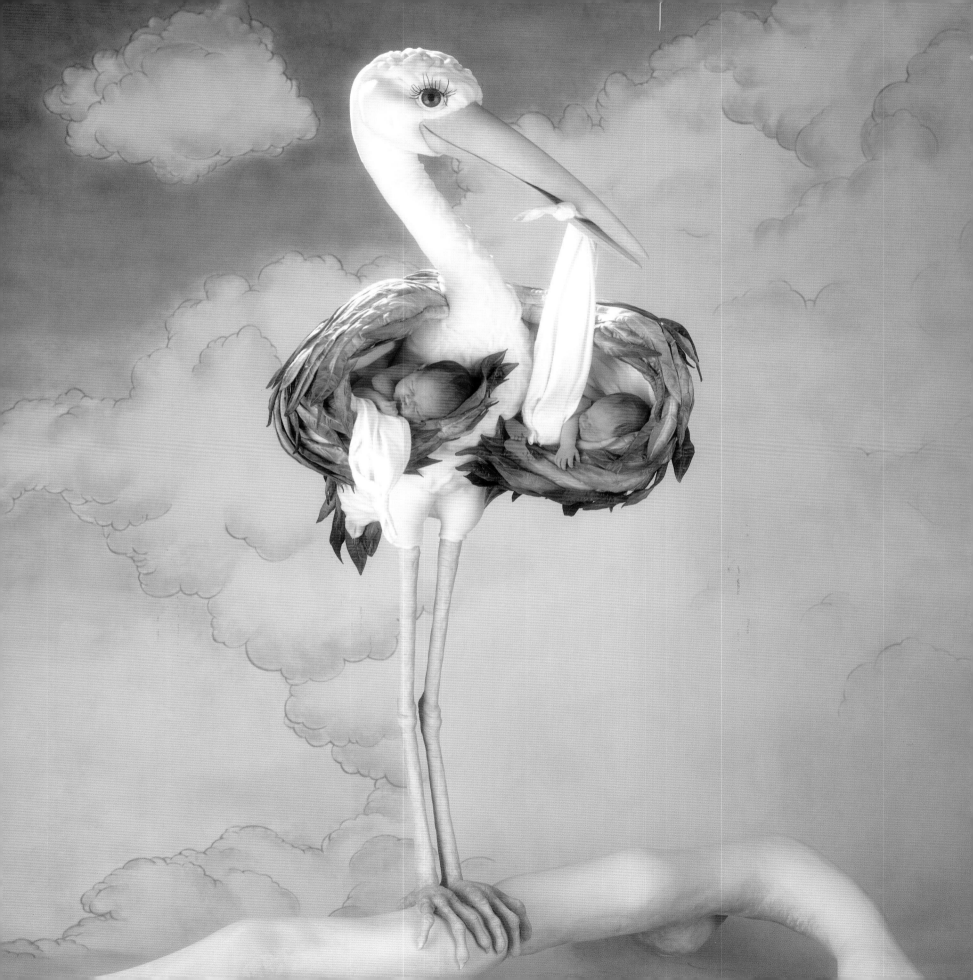

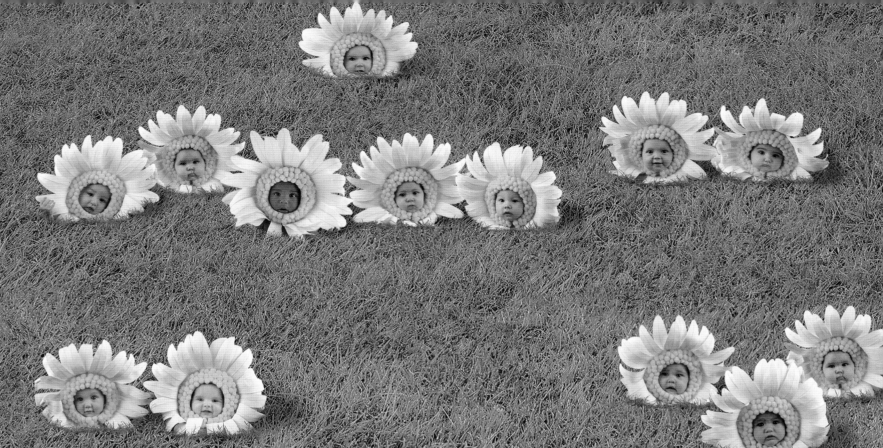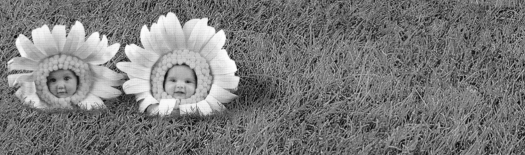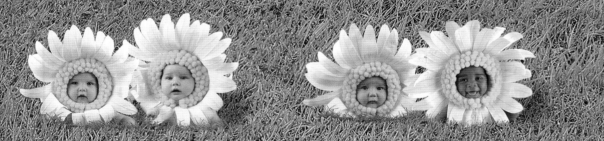

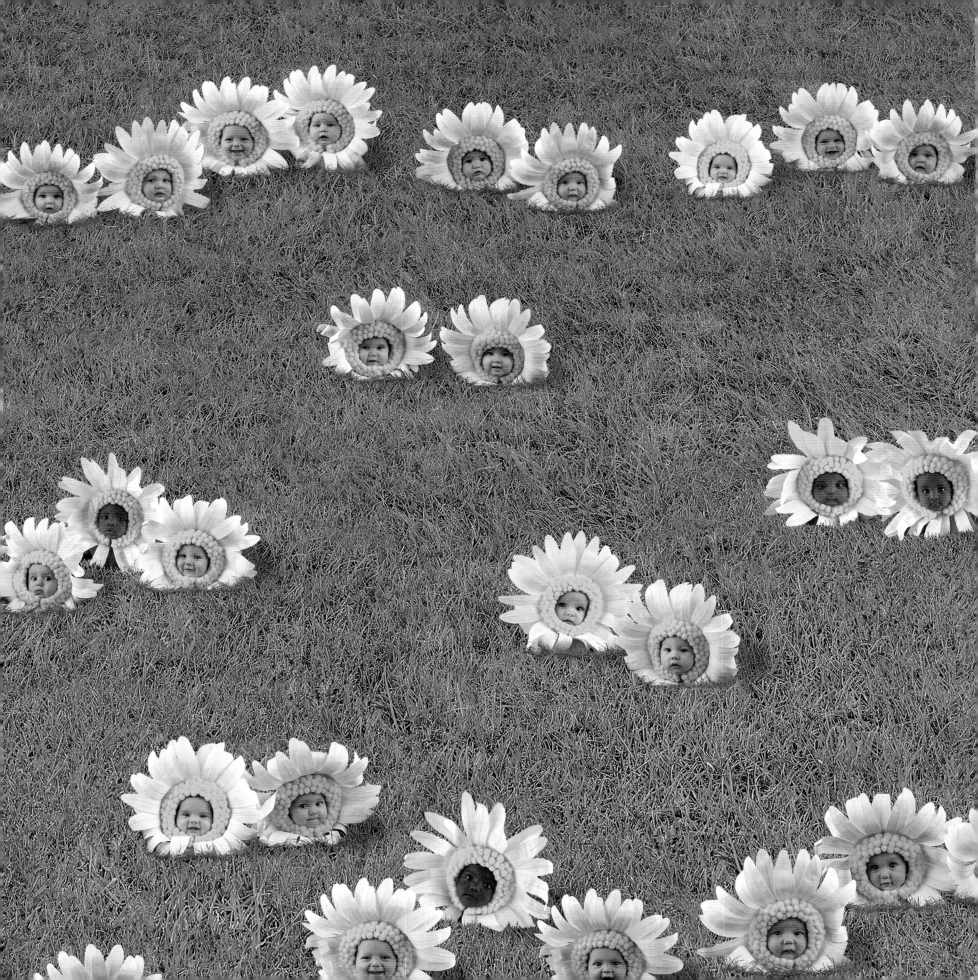

Earth laughs in flowers.

Ralph Waldo Emerson (1803–1882)

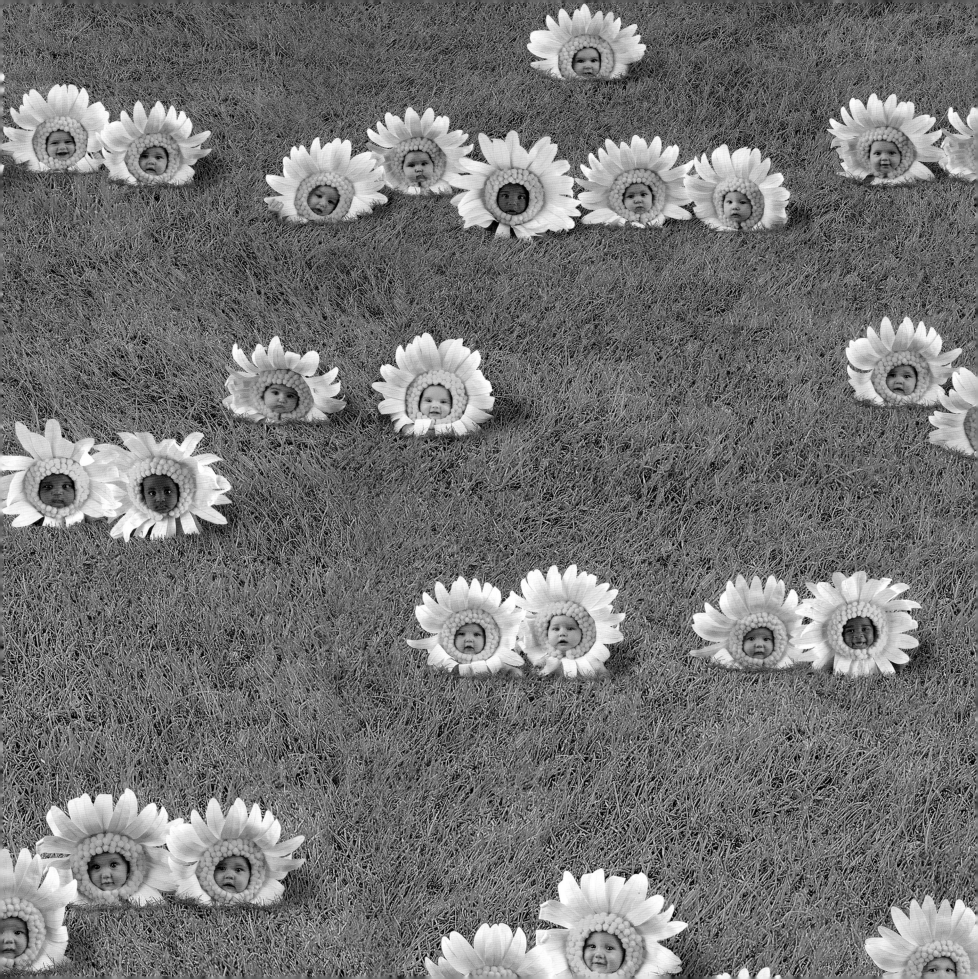

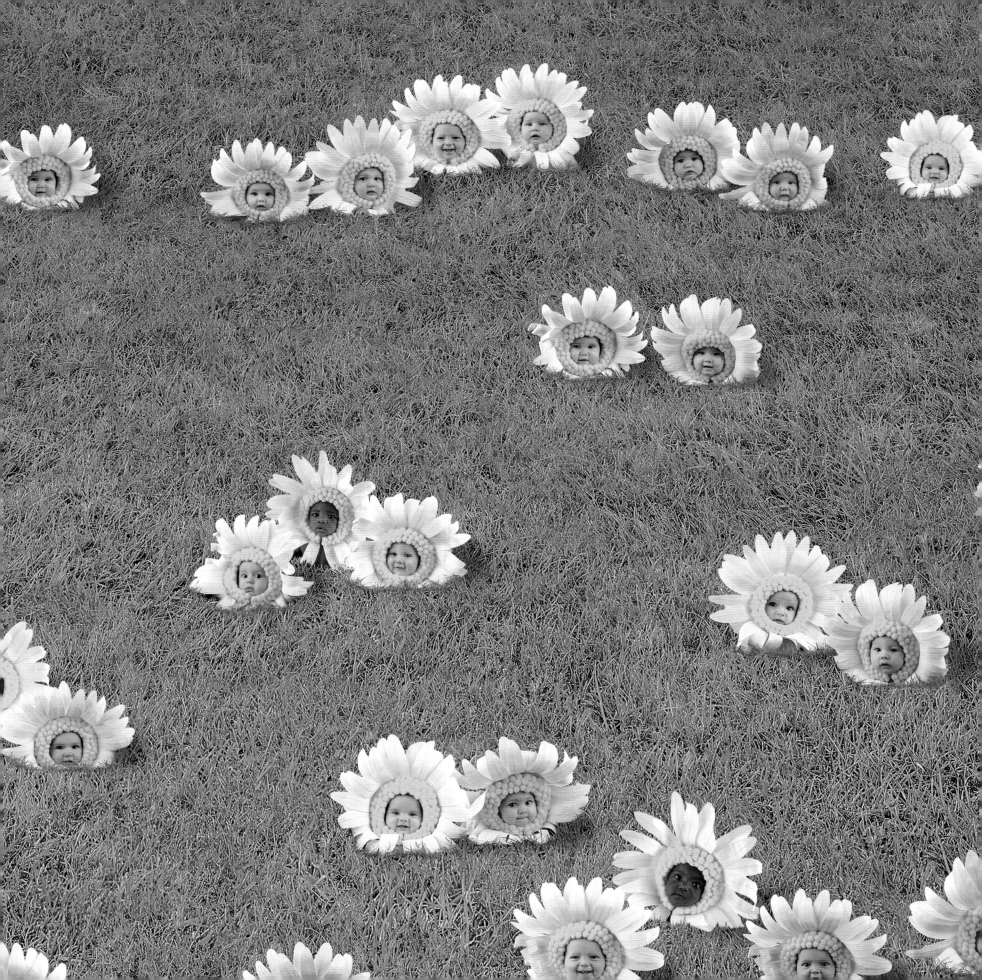

*T*he future belongs to those
who believe in the beauty of their dreams.

Eleanor Roosevelt (1884–1962)

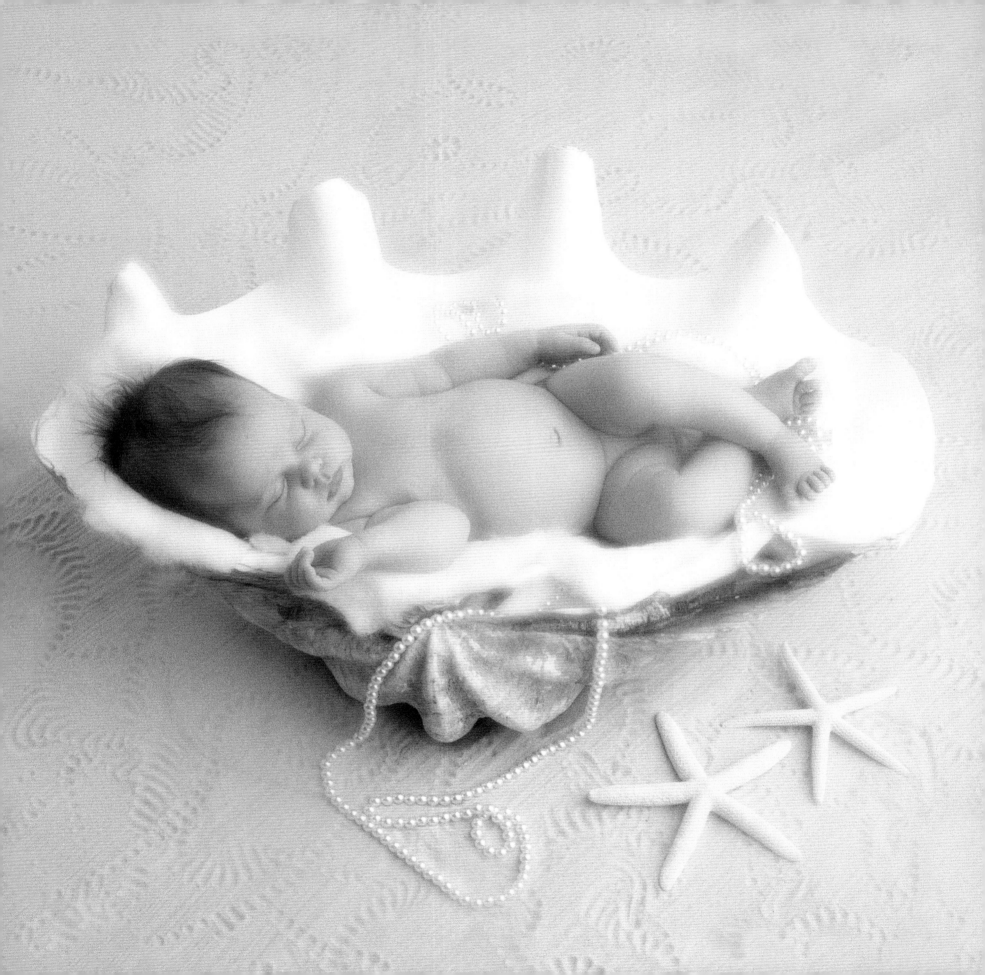

*Nothing grows in our garden,
only washing.
And babies.*

Dylan Thomas (1914–1953)

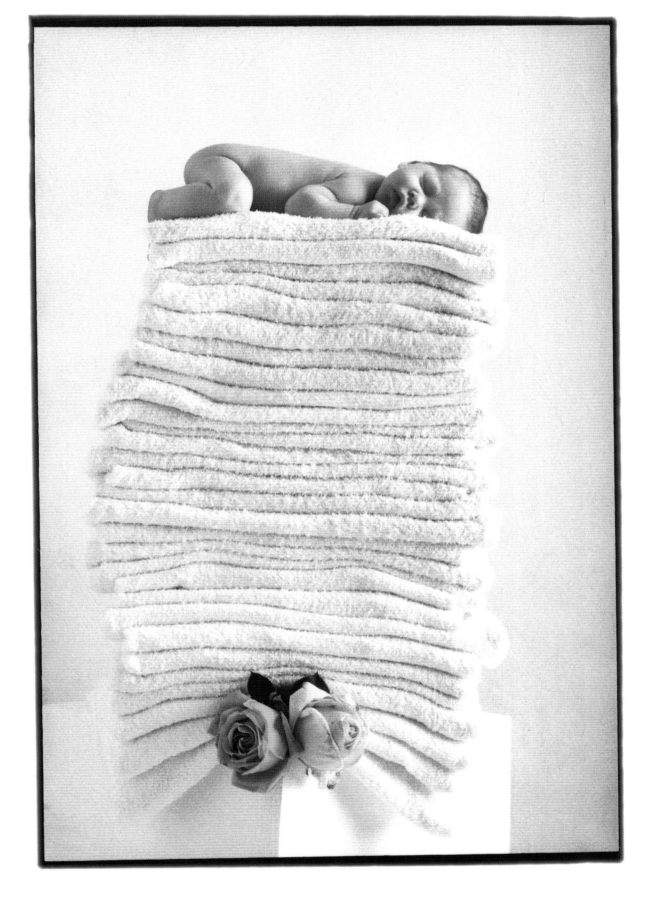

As a boon the kiss is granted:
Baby-mouth, your touch is sweet –
Takes the love without the trouble
From those lips that with it meet;
Gives the love, O pure! O tender!
Of the valley where it grows,
But the baby-heart receiveth
MORE THAN IT BESTOWS.

Jean Ingelow (1820–1897)

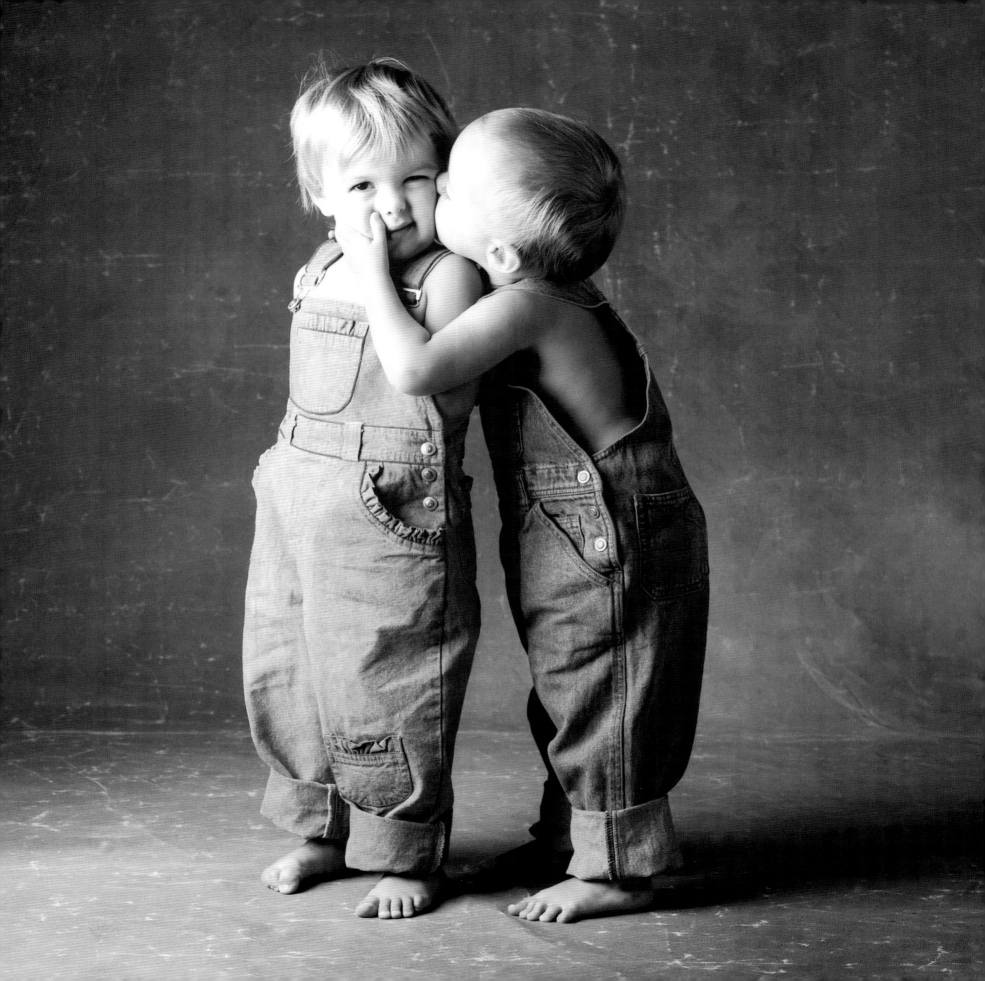

For babies people have to pay
A heavy price from day to day —
There is no way to get one cheap.
Why, sometimes when they're fast asleep
You have to get up in the night
And go and see that they're alright.
But what they cost in constant care
And worry, does not half compare
With what they bring of joy and bliss —
You'd pay much more for just a kiss.

Edgar Guest (1881–1959)

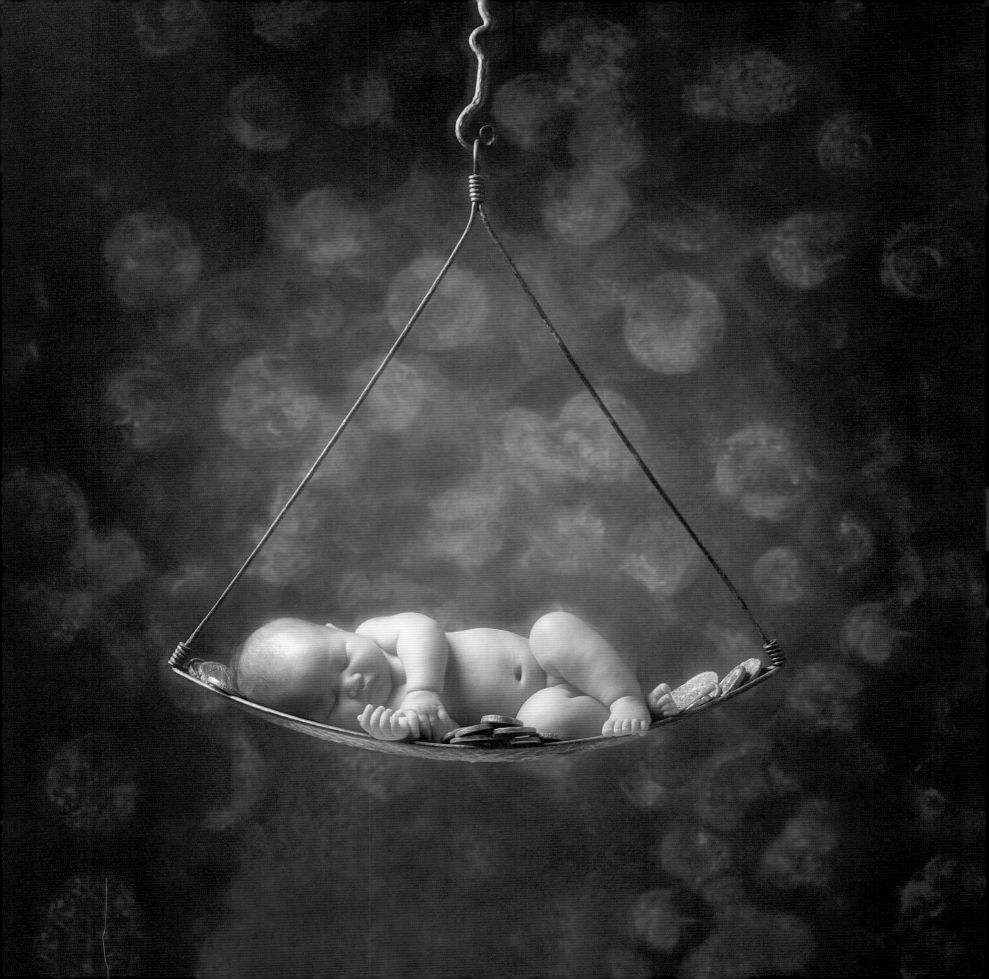

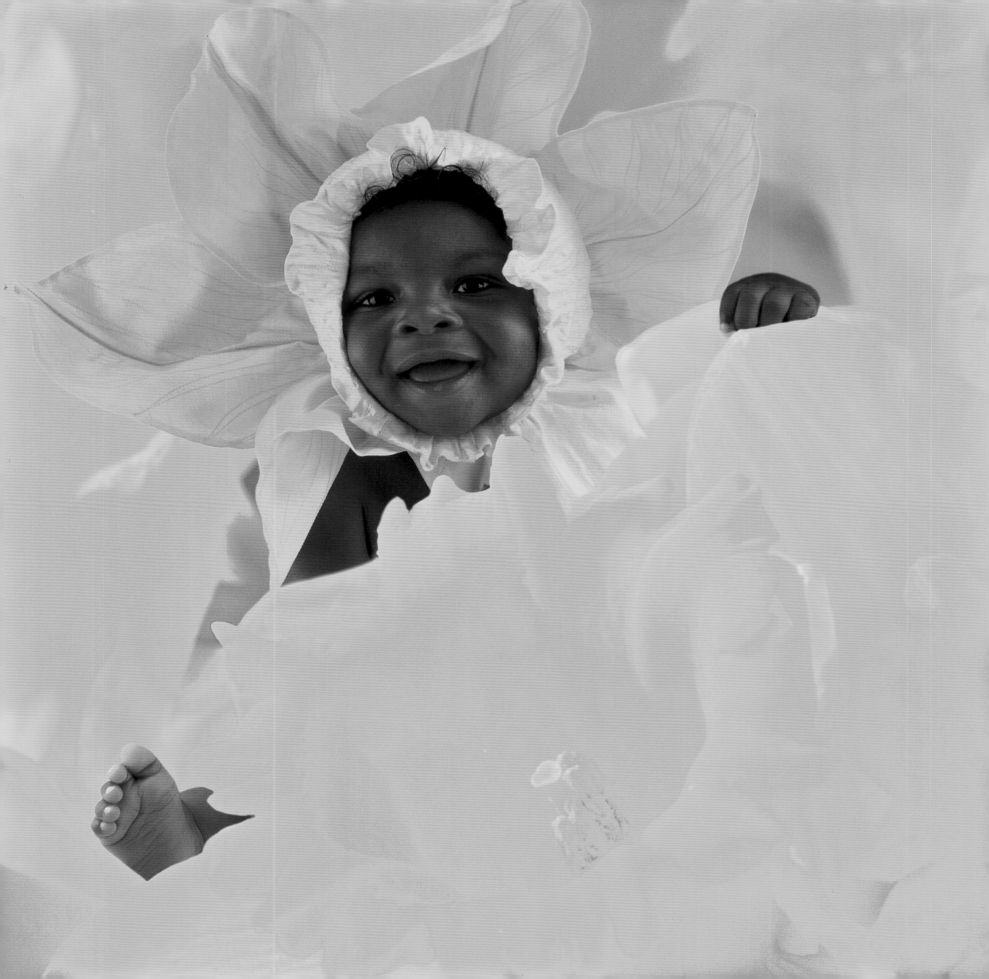

Little children are the most lovely flowers this side of Eden.

Rev. Dr. Davies

When the first baby laughed for the first time,
the laugh broke into a thousand pieces,
and they all went skipping about,
and that was the beginning of fairies.

J. M. Barrie (1860–1937)

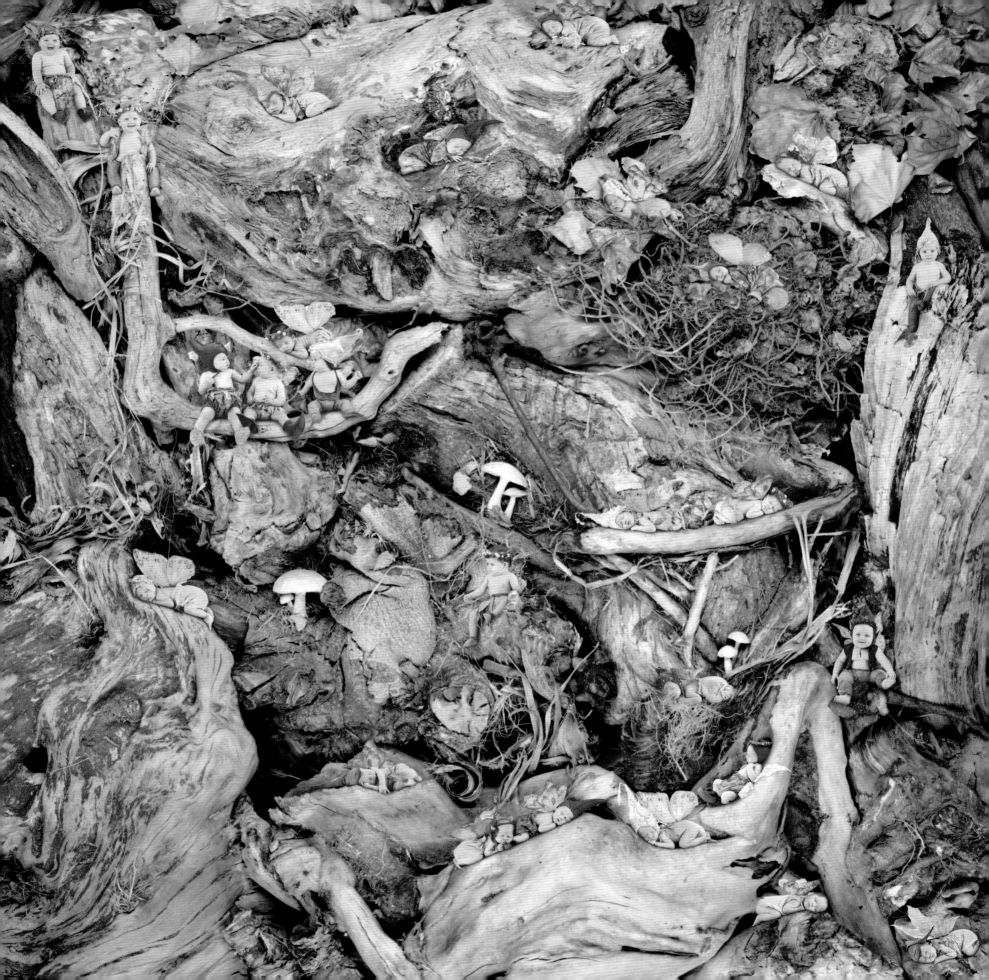

A lovely being, scarcely formed or moulded,
A rose with all its sweetest leaves yet folded.

Lord Byron (1788–1824)

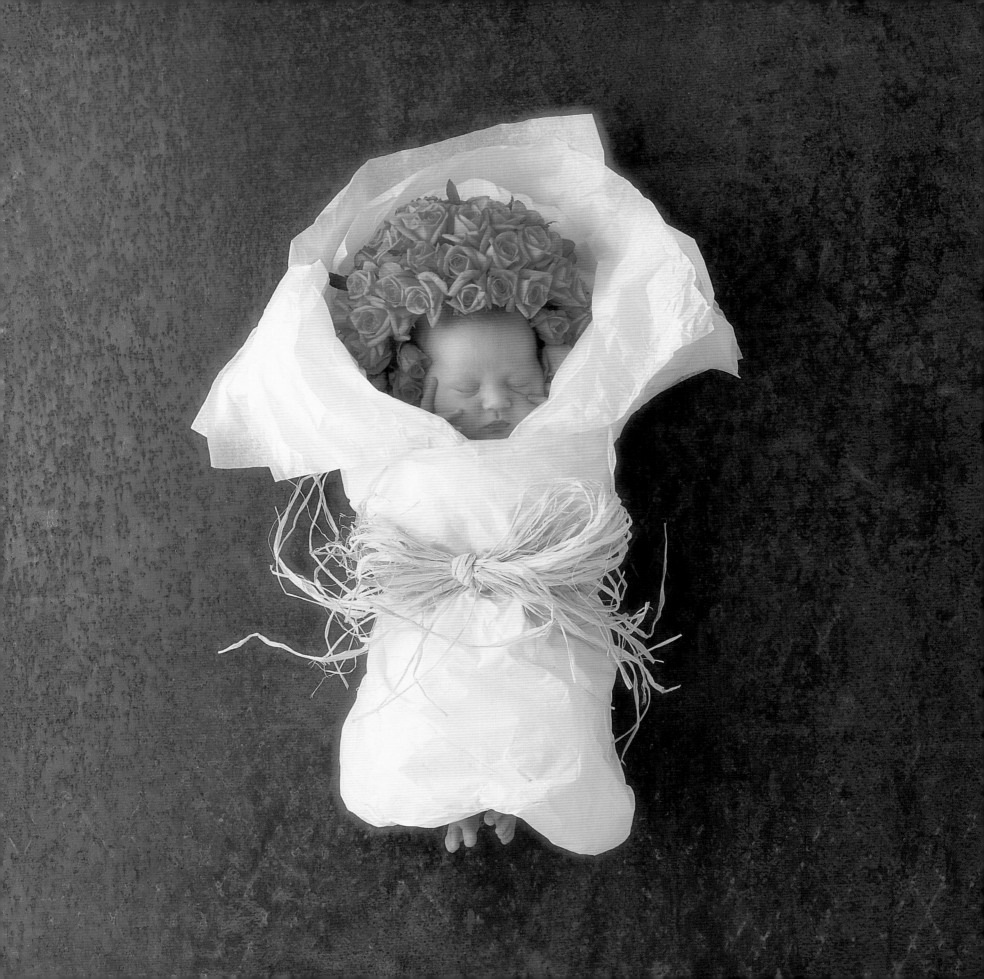

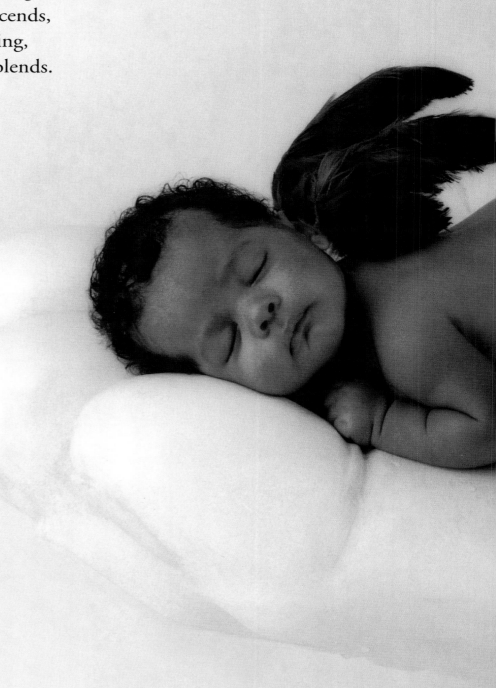

*I*t lay upon its mother's breast, a thing
Bright as a dewdrop when it first descends,
Or as the plumage of an angel's wing,
Where every tint of rainbow beauty blends.

Amelia Welby (1821–1852)

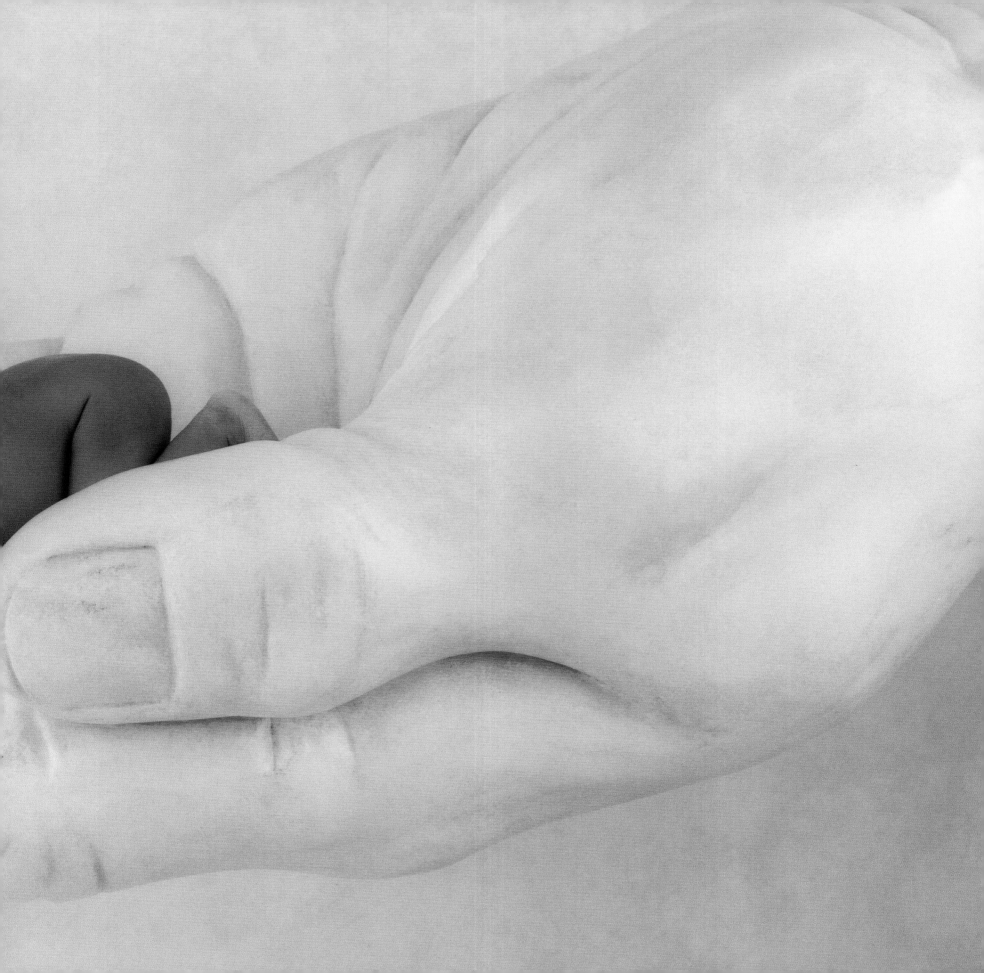

A new baby is like
the beginning of all things —
wonder, hope, a dream of possibilities.

Eda J. Leshan (1922–)

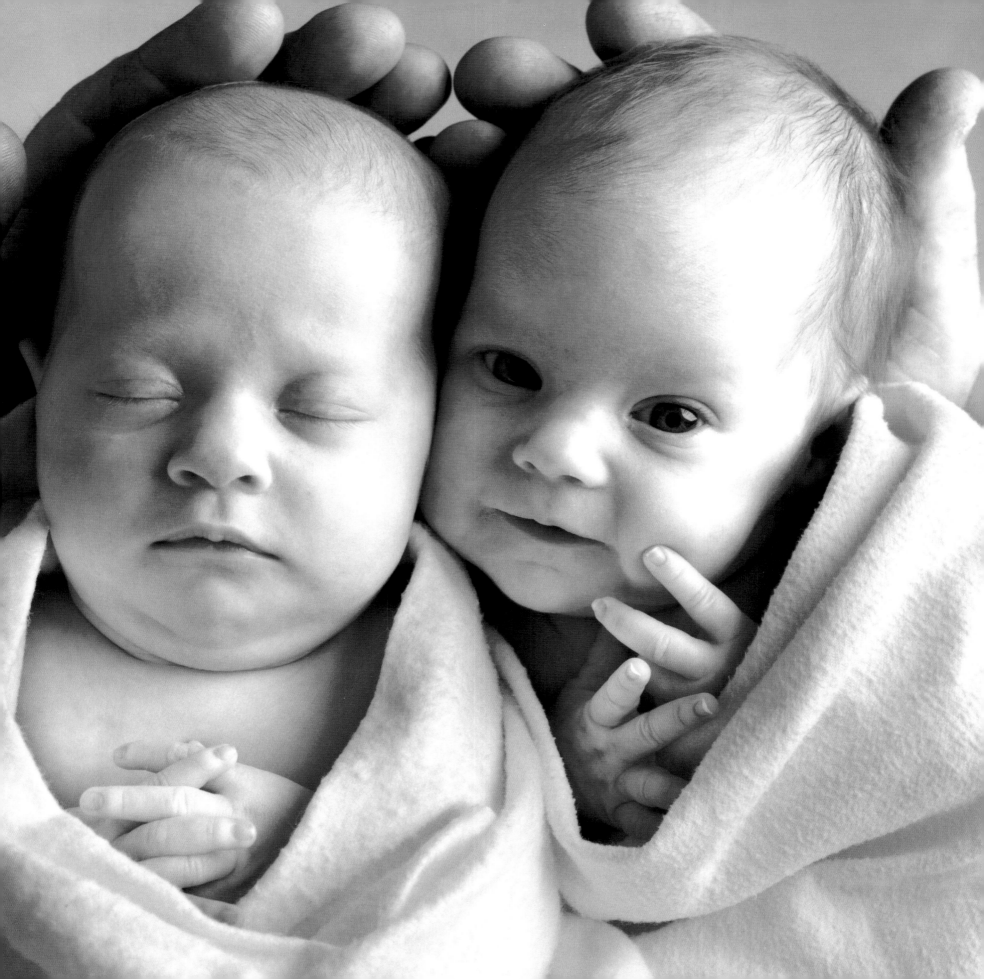

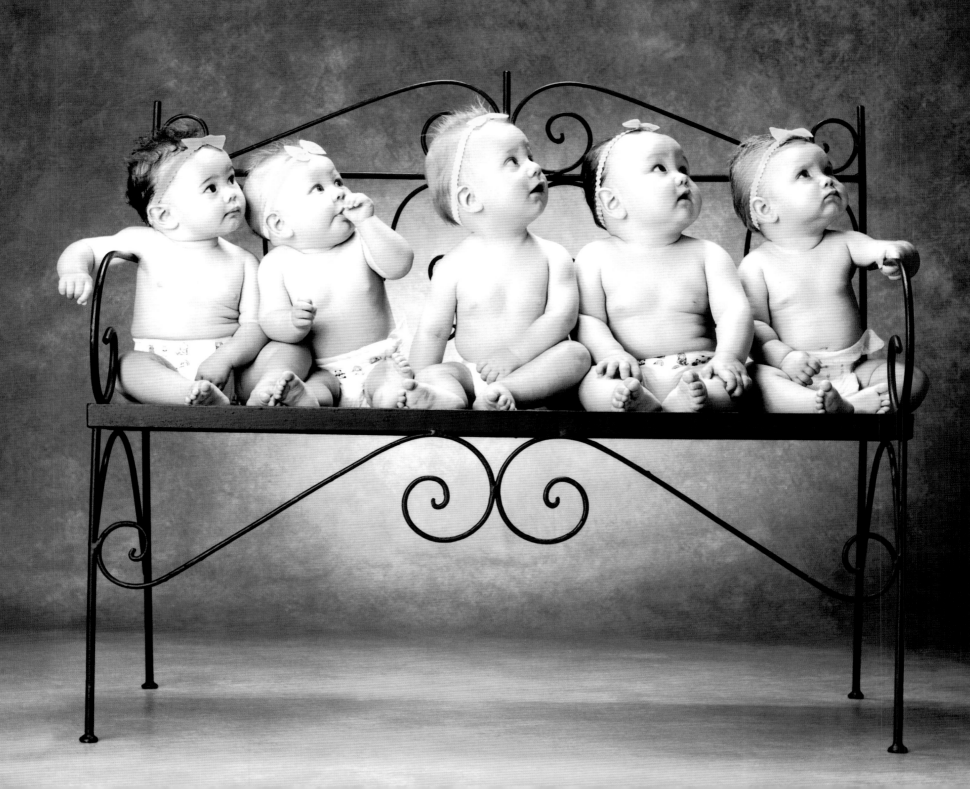

The little child, when it sees a star sparkle,
stretches out its dimpled arms; it wants that star.
To want a star is the beautiful insanity of the young.

Countess de Gasparin

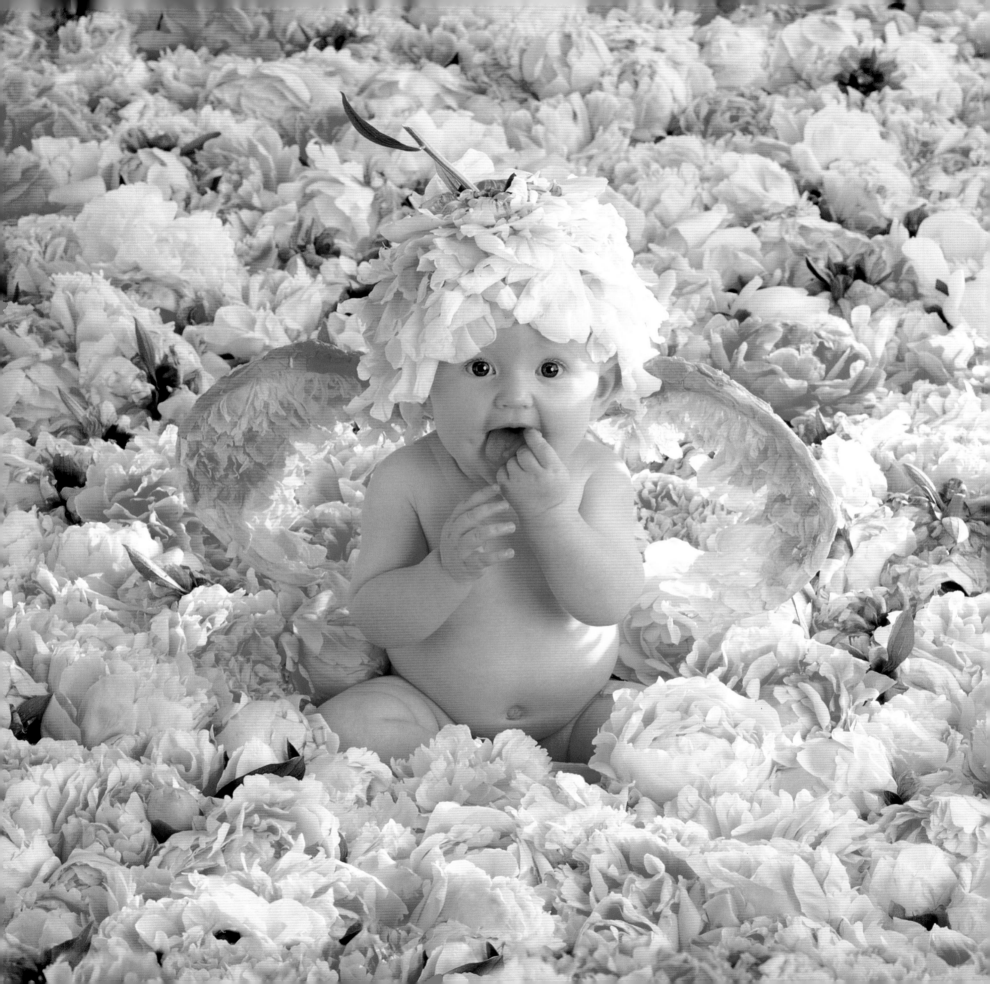

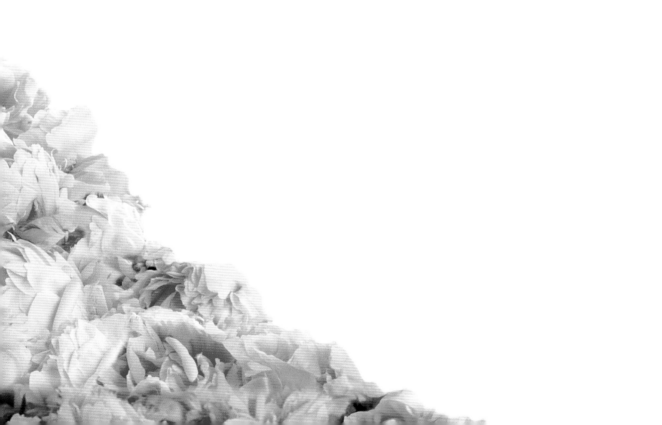

The very pink of perfection.

Oliver Goldsmith (1728–1774)

Do you know what you are?
You are a marvel. You are unique.
In all the years that have passed,
there has never been another child like you.

Pablo Casals (1876–1973)

ACKNOWLEDGEMENTS

The publisher is grateful for the permission to reproduce those items which are subject to copyright. While every effort has been made to trace copyright holders, the publisher would be pleased to hear from any not here acknowledged.

The quotations from *Great Quotes from Great Women* © 1997 Successories, Inc. are reprinted with the permission of Career Press, PO Box 687, Franklin Lakes, NJ 07417.

The quotations from *Life's Little Instruction Book Volume III* © 1995 H. Jackson Brown, Jr., are reprinted with the permission of Rutledge Hill Press, Nashville, Tennessee.

FURTHER INFORMATION ABOUT
THE QUOTATIONS

(in alphabetical order by author)

Life itself is the most …
Hans Christian Andersen (1805–1875),
Danish author

When the first baby laughed …
Do you believe in fairies …
Those who bring sunshine …
J. M. Barrie (1860–1937), Scottish novelist and dramatist, all three quotes from *Peter Pan* (1904)

Kiss your children goodnight …
Whisper in your sleeping child's ear …
H. Jackson Brown, Jr. (1940–), American writer, from *Life's Little Instruction Book Volume III*, Rutledge Hill Press, USA, 1995

Some are kissing mothers …
Pearl S. Buck (1892–1973), American novelist

Flowers always make people better …
Luther Burbank (1849–1926), American horticulturist

A lovely being … from *Don Juan* (1819–1824)
Oh! little lock of golden hue … from "To A Lady" (1806)
You should have a softer pillow … from a letter to Anne Isabella, Lady Noel Byron
Lord Byron (1788–1824), English poet

Little drops of water …
Julia A. Carney (1823–1908), from *Little Things* (1845)

There are only two lasting bequests …
Hodding Carter III (1935–), American journalist and political commentator

Each second we live …
Pablo Casals (1876–1973), Spanish classical musician, from *Chicken Soup for the Soul*, edited by Jack Canfield and Mark Victor Hansen, Health Communications, 1993

Angels can fly …
G. K. Chesterton (1874–1936), English critic, novelist and poet, from *Orthodoxy*, 7 (1908)

How soft and fresh …
Bishop Coxe (1818–1896), poet and miscellaneous writer

It was the Rainbow …
William Henry Davies (1871–1940), English poet, from
his poem "The Kingfisher"

Golden slumbers kiss your eyes …
Thomas Dekker (1570?–1632), English dramatist

There are two ways …
Albert Einstein (1879–1955), mathematical physicist

Earth laughs …
The greatest gift …
Ralph Waldo Emerson (1803–1882), American poet
and essayist

Each day I love you more …
Rosemonde Gérard, from "L'Eternelle Chanson"

The very pink of perfection.
Oliver Goldsmith (1728–1774), Irish playwright, novelist,
and poet, from *She Stoops to Conquer* (1773)

For babies people have to pay …
Edgar Guest (1881–1959), American writer, from "What
a Baby Costs," *A Treasury of Great Moral Stories*, Simon
and Schuster, 1993

The decision to have a child …
Katherine Hadley, from "Labours of Love," *Tatler,*
May 1995

Happiness is a butterfly …
Nathaniel Hawthorne (1804–1864), American novelist
and short story writer, from *American Notebooks* (1852)

As a boon the kiss is granted …
Jean Ingelow (1820–1897), English poet

A new baby is like the beginning of all things …
Eda J. Leshan (1922–), American author, from
The Conspiracy Against Childhood, Atheneum, NY, 1967

Happiness is the intoxication …
Ella Maillart (1903–), French travel writer

We can do no great things …
Mother Teresa (1910–1997), from *Great Quotes*
from Great Women, Career Press, USA, 1997

The future belongs to those …
Eleanor Roosevelt (1884–1962), American humanitarian
and wife of President Franklin D. Roosevelt, from *Great*
Quotes from Great Women, Career Press, USA, 1997

O wonderful, wonderful … from *As You Like It*
What's in a name … from *Romeo and Juliet*
William Shakespeare (1564–1616), English playwright

You too, my mother, read my rhymes …
Robert Louis Stevenson (1850–1894), Scottish author

Nothing grows in our garden …
Dylan Thomas (1914–1953), Welsh poet, from *Under*
Milk Wood, J. M. Dent, London, 1954

It lay upon its mother's breast …
Amelia Welby (1821–1852), American poet

I have spread my dreams …
W. B. Yeats (1865–1939), Irish poet

ANNE GEDDES ™

ISBN 0-7683-2020-8

© Anne Geddes 1998

Published in 1998 by Photogenique Publishers
(a division of Hodder Moa Beckett)
Studio 3.16, Axis Building, 1 Cleveland Road, Parnell
Auckland, New Zealand

First USA edition published in 1998 by Cedco Publishing Company,
100 Pelican Way, San Rafael, CA 94901

Designed by Frances Young
Produced by Kel Geddes
Color separations by MH Group

Printed through Midas Printing Limited, Hong Kong

Please write to us for a FREE FULL COLOR catalog of our
fine Anne Geddes calendars and books, Cedco Publishing Company,
100 Pelican Way, San Rafael, CA 94901
or visit our website: www.cedco.com
10 9 8 7 6